ORNATE LETTERS VECTOR DESIGNS

ORNATE LETTERS VECTOR DESIGNS

DOVERPICTURA

DOVER PUBLICATIONS, INC. | Mineola, New York

By Alan Weller.
Designed by Cristy Deming and Juliana Trotta.

Ornate Letters Vector Designs is a new work, first published by Dover Publications, Inc. in 2011.

The CD-ROM file names correspond to the images in the book. All of the artwork stored on the CD-ROM can be imported directly into a wide range of design and word-processing programs on either Windows or Macintosh platforms. No further installation is necessary.

ISBN 10: 0-486-99173-3
ISBN 13: 978-0-486-99173-3
Manufactured in the United States of America by Courier Corporation
99173301
Dover Publications, Inc., 31 East 2nd Street, Mineola, NY 11501
www.doverpublications.com

GALLERY–PAGES 1, 2, 4, 8 thru 25

Provides you with examples, from basic to complex, of compositions designed using vectors and textures from the accompanying CD. On the right-hand side of each pair of pages is an "asset panel," in which you will find a listing of all of the components and colors that were used in the creation of the illustrations.

TUTORIALS–PAGES 26 thru 45

Contains instructional materials pertaining to the examples shown in the Gallery section of this book. Use this section to learn how to work with vector images and to create your own compositions in Adobe Illustrator. These tutorials will teach you about basic elements such as shapes, paths, and anchor points, and will give you step-by-step instructions for coloring, reshaping, scaling and patterning.

BACKGROUND TEXTURES–PAGES 46 and 47

Shows simple, clean renderings of all of the background textures that are on the accompanying CD.

VECTORS–PAGES 48 thru 128

Shows simple, clean renderings of all of the vector images that are on the accompanying CD.

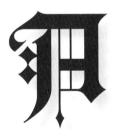 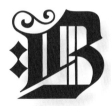 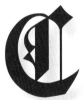

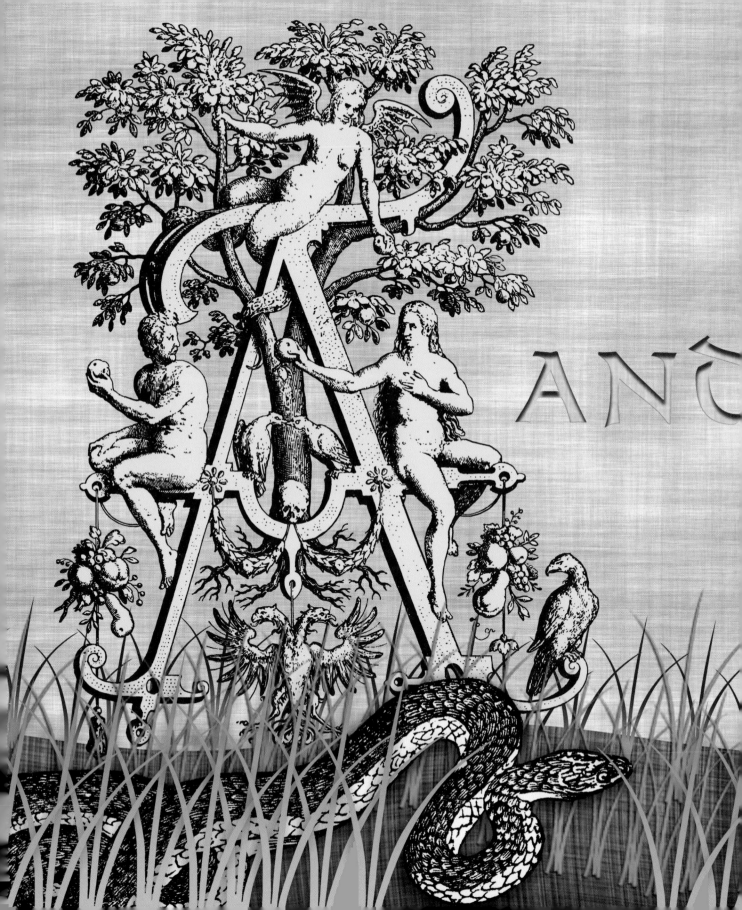

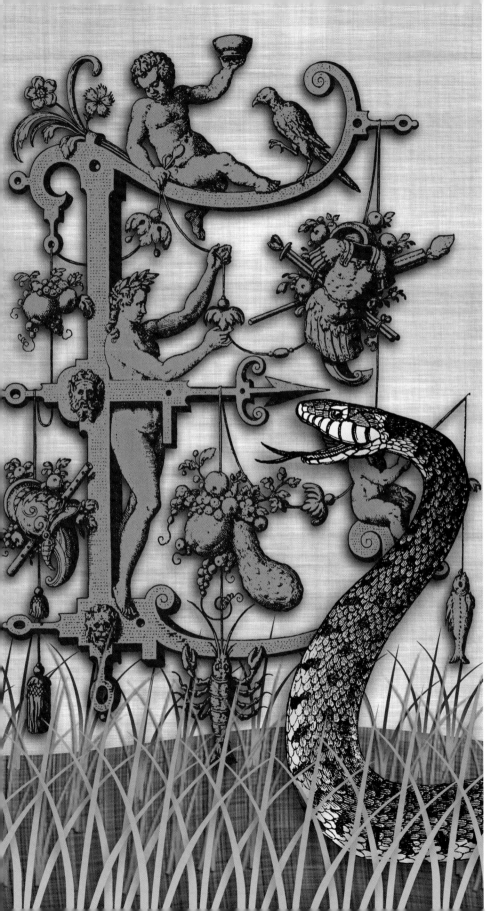

042

127

086 099 089

456 458

457

BT 012 BT 002

Techniques Used:

Fill, Gradient, Drop & Inner Shadow, Outer Glow,
Photoshop Brush Tool, Hue & Saturation,
Scale, Texture

	42c	79m	38y	11k
	29c	0m	10y	0k
	77c	19m	99y	4k
	144r	77g	108b	
	193r	216g	47b	
	65r	149g	69b	

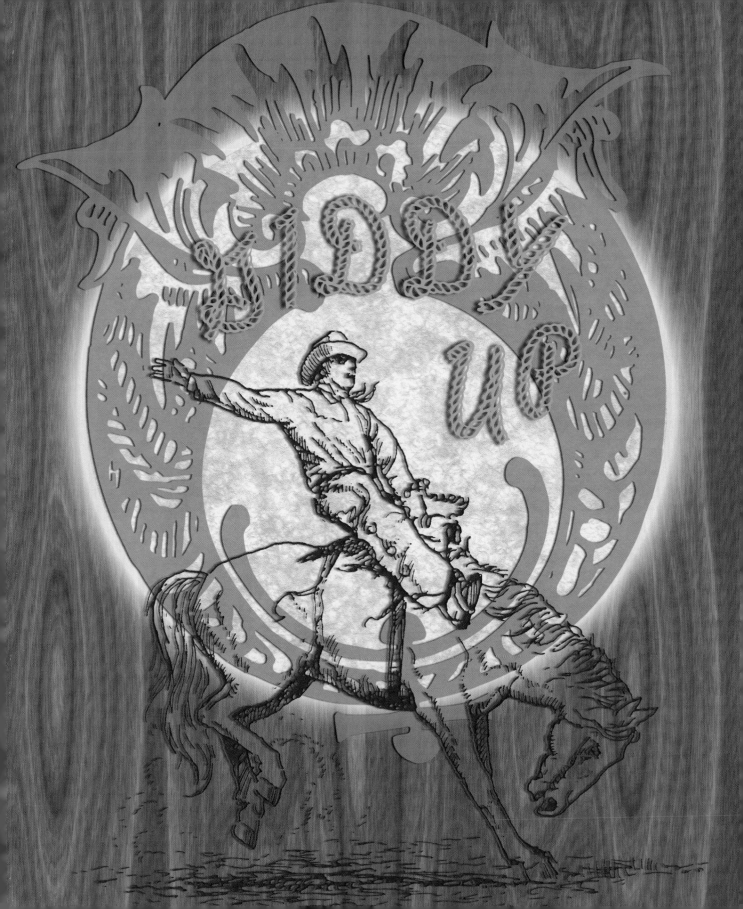

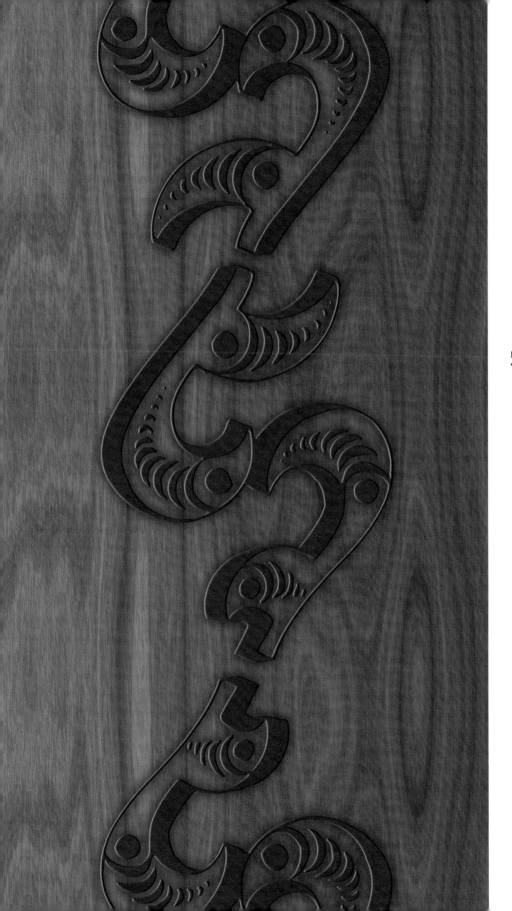

330

372

140 142 137 158 154 149

460

BT 003 BT 040

Techniques Used:
Fill, Gradient, Drop & Outer Shadow,
Bevel, Hue & Saturation, Scale, Rotate

57c	58m	81y	54k
33c	90m	88y	44k
74c	10m	27y	0k
8c	52m	100y	0k
71r	61g	39b	
113r	37g	30b	
30r	172g	185b	
229r	140g	30b	

IT WAS A DARK A

STORMY NIGHT

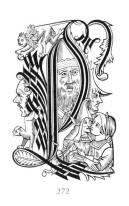

272

| 299 | 309 | 312 | 290 | 308 |
| I | T | W | A | S |

| 293 | 307 | 300 | 303 | 309 |
| D | R | K | N | T |

| 304 | 302 | 314 | 296 | 297 |
| O | M | Y | G | H |

BT 001 BT 027 BT 036

Techniques Used:

Fill, Gradient, Drop Shadow, Outer Glow,
Hue & Saturation, Bevel, Scale

70c	62m	59y	49k
58c	62m	51y	29k
13c	0m	94y	0k

59r	61g	63b
97r	82g	88b
235r	247g	36b

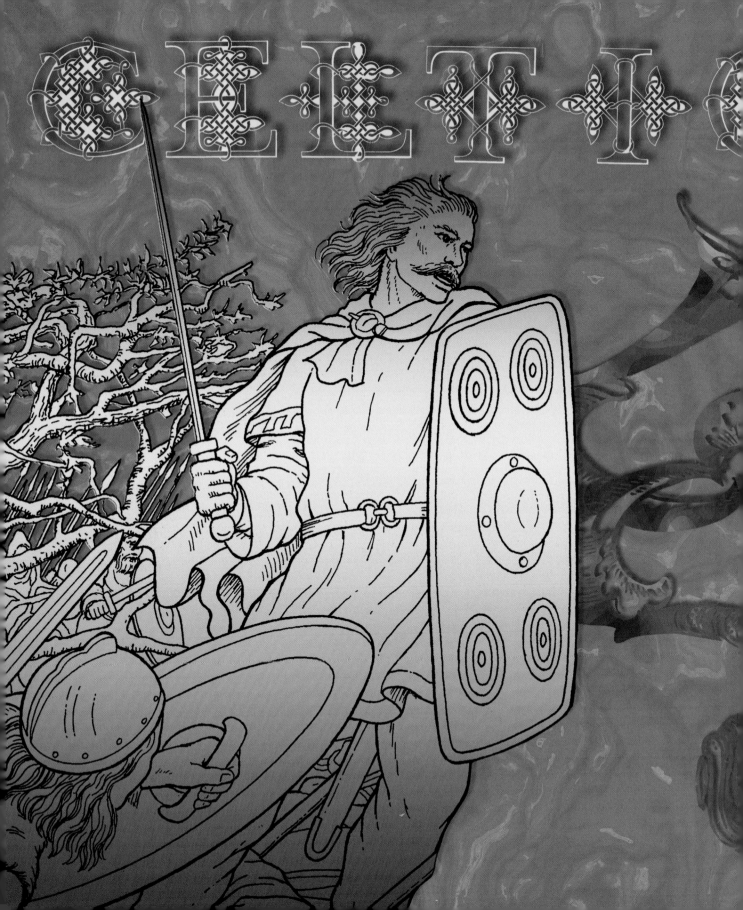

CELTIC

281

407 178

180 187 195 184

459

| BT 019 | BT 021 | BT 004 |

Techniques Used:
Fill, Gradient, Inner Shadow, Drop Shadow,
Hue & Saturation, Bevel

64c	80m	45y	39k
15c	84m	31y	0k
19c	86m	76y	8k
12c	6m	99y	0k

80r	51g	75b
210r	78g	121b
187r	69g	66b
231r	217g	24b

15

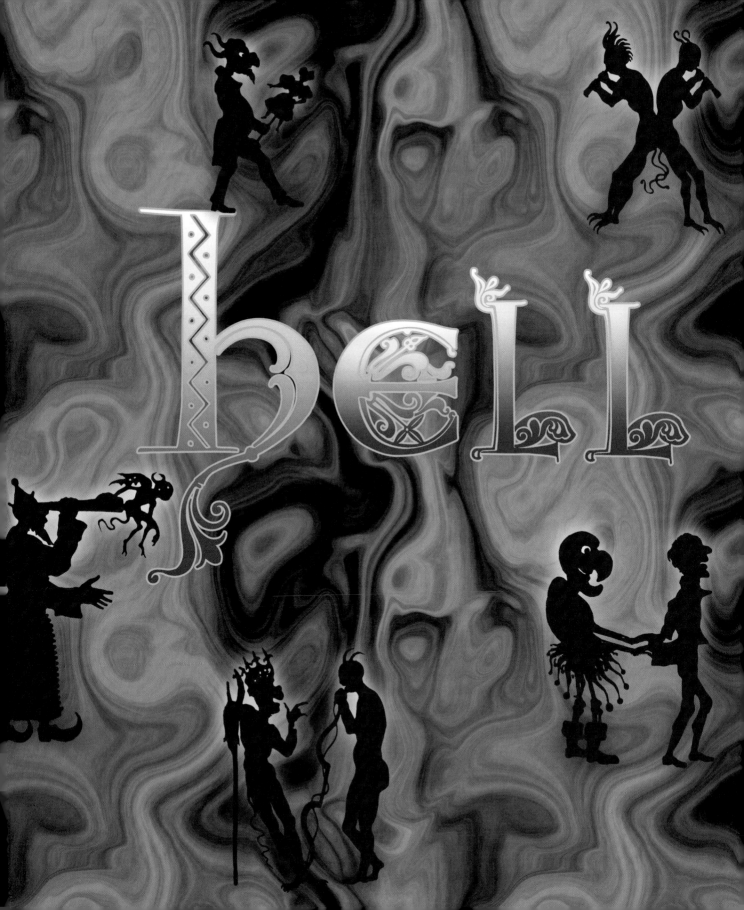

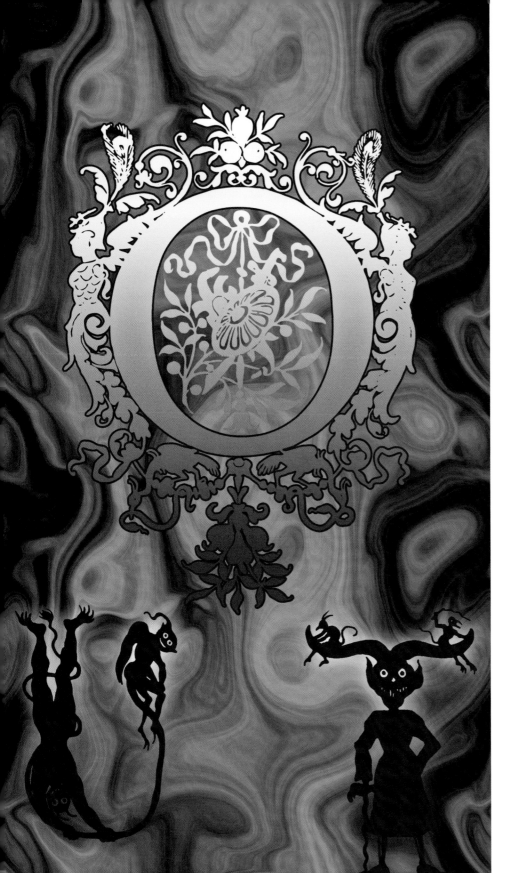

324

212

131

275

223

238

225

228

239

237

230

BT 033

Techniques Used:
Fill, Gradient, Outer Glow, Drop Shadow,
Gaussian Blur, Hue & Saturation, Scale

82c	44m	69y	36k
25c	100m	100y	21k
0c	72m	100y	0k
5c	0m	91y	0k
42r	87g	73b	
158r	27g	27b	
243r	106g	3b	
255r	247g	20b	

17

THE PEN IS MIGHTIER THAN THE SWORD

350

271

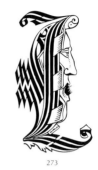

356

273

T h e p
105 093 090 101

N I S M
099 094 104 098

G R A W
092 103 086 108

O D
100 089

BT 021

Techniques Used:

Fill, Gradient, Drop Shadow, Bevel,
Hue & Saturation, Scale, Inner Shadow

	100c	100m	33y	46k
	32c	37m	46y	1k
	48c	42m	40y	5k
	8c	5m	40y	5k
	27r	14g	71b	
	176r	153g	135b	
	138r	135g	136b	
	234r	231g	203b	

19

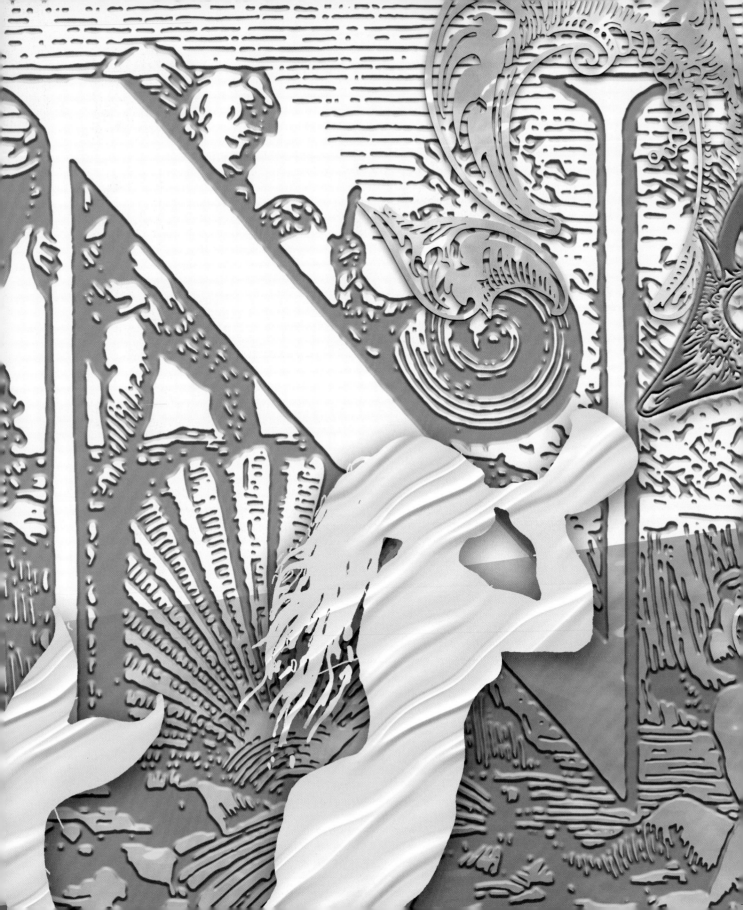

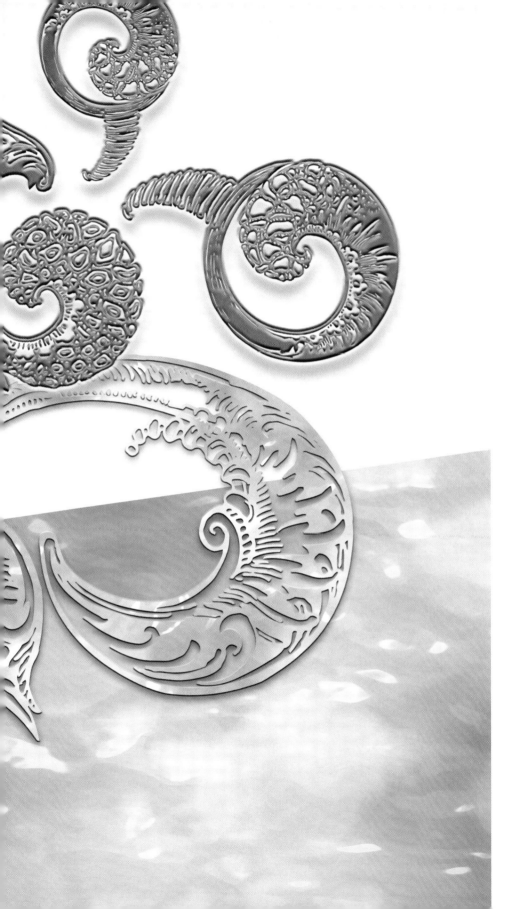

321

355

403

392

227

BT 028

BT 034

Techniques Used:

Fill, Gradient, Drop Shadow, Outer Glow,
Hue & Saturation, Bevel, Scale

	67c	85m	29y	13k
	80c	27m	39y	2k
	54c	0m	50y	0k
	7c	0m	6y	0k
	103r	64g	113b	
	37r	142g	150b	
	114r	205g	158b	
	233r	245g	238b	

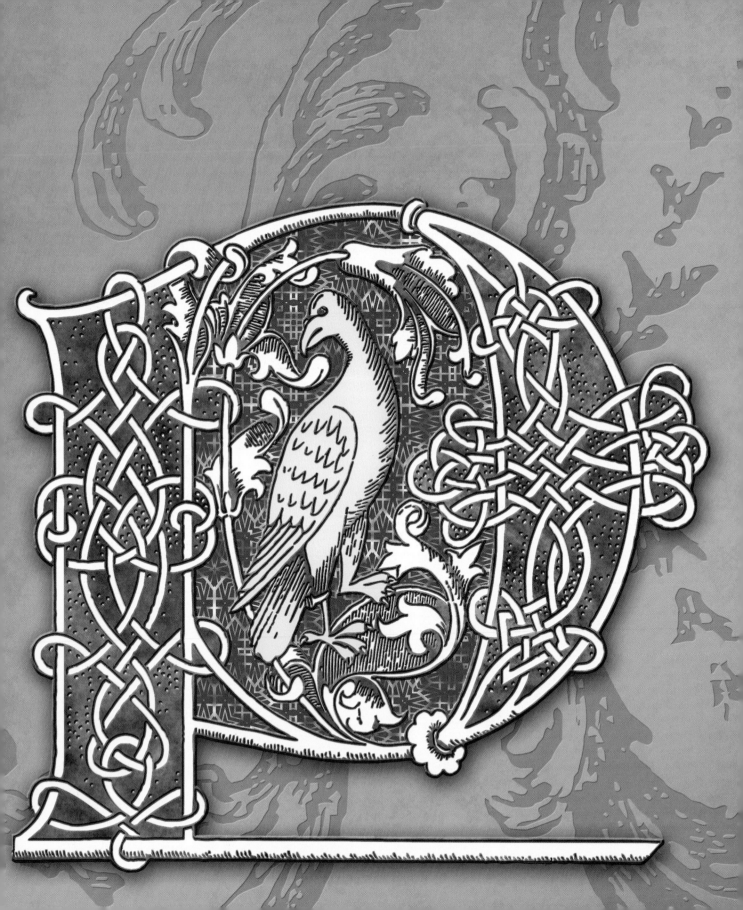

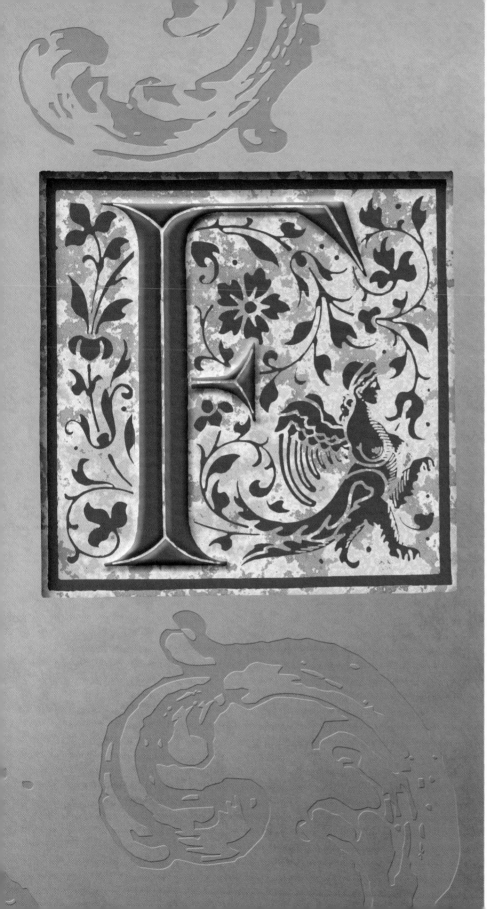

344

171

260

BT 020 BT 005

Techniques Used:

Fill, Gradient, Clipping Mask, Inner Glow, Scale, Rotate, Drop Shadow, Bevel

74c	47m	89y	49k
22c	75m	93y	11k
43c	37m	80y	11k
2c	2m	87y	0k
50r	72g	40b	
178r	86g	47b	
145r	135g	78b	
255r	235g	59b	

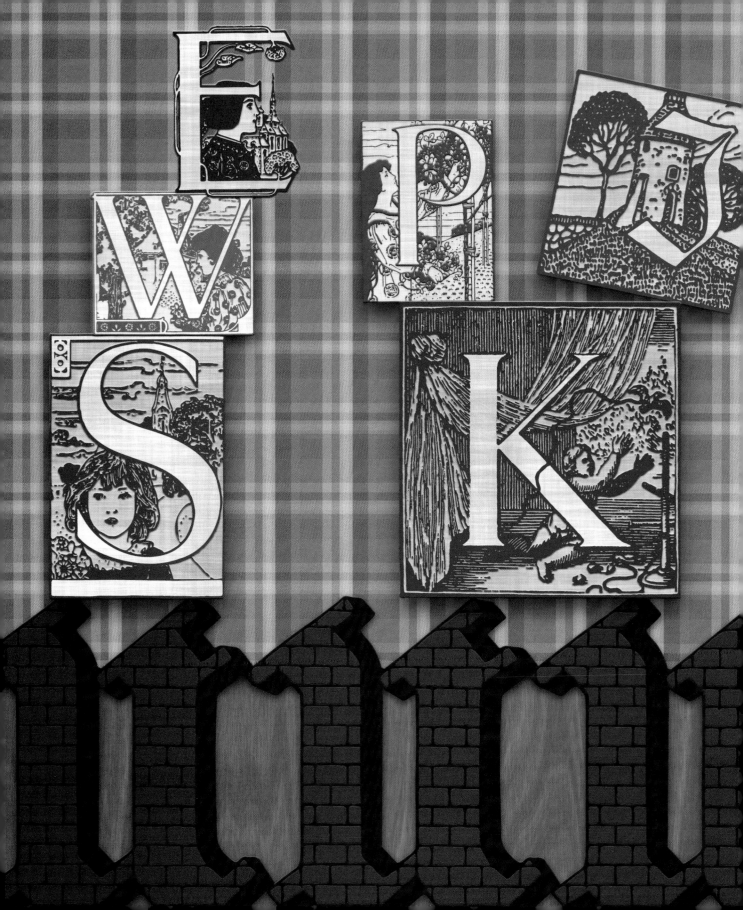

129

337

257

374

250

406

445

383

401

397

BT 003 BT 016

Techniques Used:

Fill, Bevel, Drop Shadow, Hue & Saturation, Scale, Texture

19c	52m	100y	3k
27c	100m	100y	27k
0c	37m	99y	0k
4c	80m	100y	0k
203r	133g	42b	
146r	26g	28b	
251r	171g	28b	
232r	88g	36b	

About These Tutorials

The following are basic instructional tutorials for the techniques used to create the illustrations within the Gallery section of this book. These illustrations were created using Adobe Illustrator, and a basic working knowledge of this program is important to mastering these techniques. More in-depth information about this program can be found under the Adobe Illustrator Help tab, or by visiting the Adobe website at www.adobe.com.

These tutorials have been performed using the Macintosh version of Adobe Illustrator CS2. If you have a newer or older version of Illustrator, some variation could occur in how your software displays the tools used in these tutorials. Also, there are minor differences in functionality and nomenclature between the Windows and Macintosh versions of Illustrator. Consult your Illustrator manual or the Help tab if you do not find the Tool, Window, Menu, or Palette described in the tutorial.

Opening Vectors in Illustrator

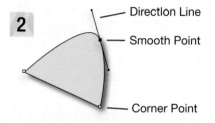

Step 1

Steps 2-5

1. On the top menu bar, go to the drop-down menu File>Open.

2. In the Open Window, locate the Dover CD which is in your computer's CD drive, double click.

3. Double click on the "Images" folder.

4. Double click on the subfolder that contains the image that you wish to open.

5. Double click on the vector file that you wish to open.

Some Basics about Vectors

Unlike bit-mapped images which are composed of pixels, vector graphics use points, lines, and curves to define shapes. Because of this they are "resolution independent," and can be reshaped, scaled, or resized without a loss of image quality. Please note that the final quality of your image will be determined by the resolution of your printer, or when viewing on-screen, by the quality of your monitor.

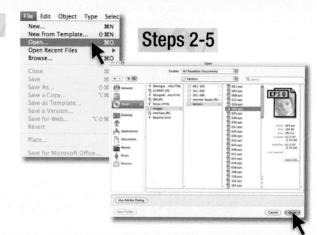

Direction Line

Smooth Point

Corner Point

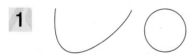

1. A vector "path" can either be open (like the curved line) or closed (like the circle).

2. Paths are made up of segments that create the entire shape. Each segment is defined by anchor points. Anchor points can be corner points or smooth points; points can be manipulated using direction lines to change the curvature of the segment.

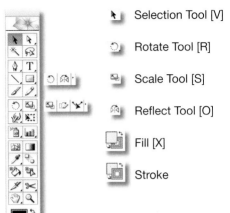

Selection Tool [V]

Rotate Tool [R]

Scale Tool [S]

Reflect Tool [O]

Fill [X]

Stroke

This is a list of the basic tools used in the tutorials. If the tool bar is not displayed it can be accessed from the top menu bar by going to Window>Tools. The tool bar is extremely handy, and gives quick access to the basic design tools. Some variant tools are hidden from view, and can be accessed by clicking and holding down the mouse over a related tool's icon. Tools with variants have small arrows in the bottom right hand corner of their icon.

To learn more about the tool bar, search under the Help tab, or in the manual that accompanied your software.

This is a list of the basic Palettes used in the tutorials. Most Palettes can be accessed from the top menu bar by going to Window>Palettes.
Please note that in Adobe Illustrator Palettes can also be referred to as Windows.

Swatches Palette Layers Palette Gradient Palette Transform Palette Align Palette

In addition to Adobe Illustrator and Photoshop, for which we have included instructional material within this book, there are many other software programs that allow you to use and edit vector-based images. Most of these programs are proprietary and must be purchased, however, there are several open-source, freeware and shareware programs available for download over the Internet. A good resource for information about both commercial and free software can be found at the following link:

http://en.wikipedia.org/wiki/List_of_vector_graphics_editors

There are several basic types of software programs with which vector images can be utilized.
The following is a list of the most popular, by category.

Illustration:

Adobe Illustrator	www.adobe.com/products/illustrator
Corel Draw	www.corel.com
Microsoft Expression Suite	www.microsoft.com/expression

Page layout:

Adobe InDesign	www.adobe.com/products/indesign
Quark XPress	www.quark.com
Scribus	www.scribus.net

Web and web animation:

Adobe Flash	www.adobe.com/products/flash
Adobe Fireworks	www.adobe.com/products/fireworks

Photo editing:

Adobe Photoshop	www.adobe.com/products/photoshop
Paint Shop Pro	www.corel.com

Image editors:

Xara Xtreme	www.xara.com
Inkscape	www.inkscape.org

27

About Dover Vectors

Most of the vector images contained in this book come from rare, old sources. In creating these vectors we have tried to maintain the unique intrinsic qualities of the original artwork, while imbuing them with all of the utility that the vector file format affords. Generally, the images in this publication are of two types: regular, closed-cell illustrations which can be "released" into individual, manipulable shapes; and more expressive, "hand-drawn" illustrations. Please note that because of the complex nature of the latter, the best results in working with this type of image require a fast computer with large allocation of RAM. The simplest method for making more RAM available to Adobe Illustrator is to shut down all unnecessary software programs.

The expressive potential of compositions made with vector images is limitless. In addition to print layouts they can be used to create silkscreen stencils, embroidery patterns, or signage designs to be cut in vinyl. They can be combined with bit-mapped images, used as paths along which type can be flowed, or as texture in multilayered compositions. Vectors tend to be relatively small files, and work very well with programs that generate web graphics, such as Adobe Flash and Fireworks. We encourage you to experiment with these images and to be creative!

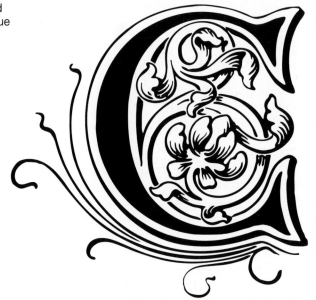

Scaling an Image in Illustrator

1. Select the image using the Selection Tool found at the top left corner of the tool bar [V]. A box will appear around the image.

2. Grab one of the corners of the box and drag it out diagonally to enlarge it. To reduce the image, drag it in. To scale the image proportionally, hold down the shift key while dragging.

3. Enlarged image.

4. You can also enlarge the image with the Transform Palette. Click the chain icon at the right of the palette to link the width and height together and scale proportionally.

5. To scale proportionally, enter either the desired width or height. To scale non-proportionally, both width and height must be entered.

6. Try the Scale Tool [S] found in the tool bar to achieve similar results.

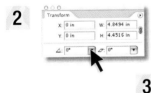

TUTORIALS

This is also called reflecting the image.

1. Select the image using the Selection Tool found at the top left corner of the tool bar [V].

2. On the top menu bar, go to the drop-down menu Window>Transform to open the Transform Palette. Click on the arrow in the upper right hand corner of the palette.

3. Choose Flip Horizontal.

4. The image should be a mirror "reflection" of the original image.

5. This process can also be achieved using the Reflect Tool [O] found in the tool bar.

Rotating an Image in Illustrator

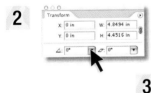
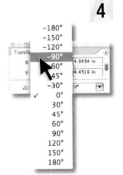

1. Select the image using the Selection Tool found at the top left corner of the tool bar [V].

2. On the top menu bar, go to the drop-down menu Window>Transform to open the Transform Palette. Click on the arrow next to the rotate input field at the lower left of the palette.

3. Select the desired angle from the pop-up list or enter the desired angle directly into the field.

4. The image should rotate.

5. The Rotate Tool [R] found in the tool bar can produce similar results.

Adding Color to Your Palette in Illustrator

At some point you will want to add colors to your palette. Here is one way to do this.

1. On the top menu bar, go to the drop-down menu Windows>Swatches. This will open the Swatches Palette window. Select a color swatch. Click the Add New Swatch button in the lower right corner of the window next to the trash can.

2. The Swatch Options window should appear. Change the color using the sliders at the bottom of the palette. You can change the mode using the drop-down Color Mode button. The global option will allow you to assign a color and change it globally in your document. Color type can be either Spot for PMS spot colors or Process for CMYK process colors.

3. When you finish creating the color swatch, type in a name for it and click the OK button.

4. Figure 4 shows the new orange swatch in the palette.

5. To add additional colors, repeat steps 1, 2, and 3.

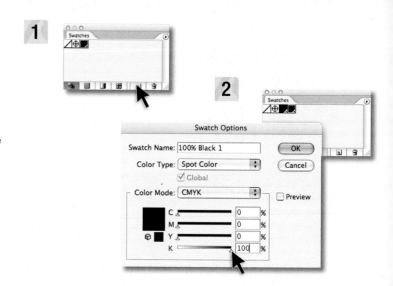

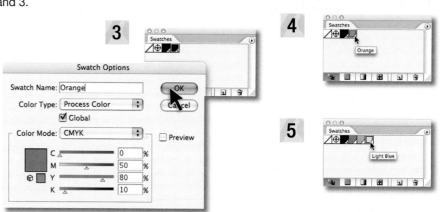

Using a Limited Palette

A limited color palette helps you organize, harmonize, and set the mood for individual projects. A cool palette might consist of blues and grays; while a warmer palette would have more reds and yellows. If you are designing an image of a sunset, you won't need cool colors, so why add them to your palette?

Most of the examples shown in this book give the color palette used for both CMYK and RGB color modes.

	0c	50m	80y	10k
	30c	0m	30y	0k
	30c	0m	10y	0k

	223r	135g	65b
	179r	221g	192b
	174r	223g	228b

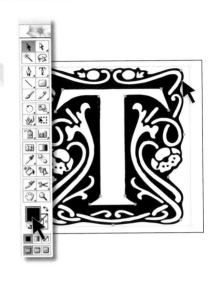

1. Select the image using the Selection Tool found at the top left corner of the tool bar [V].

 Select the fill square from the tool bar [K].

2. Fill the image by clicking on a color from the Swatches Palette window.

Strokes or Outlines in Illustrator

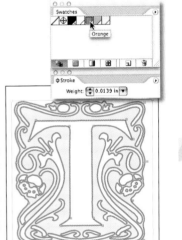

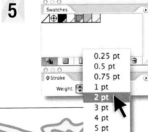

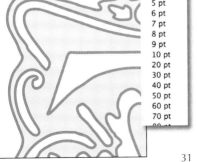

1. Select the image using the Selection Tool found at the top left corner of the tool bar [V].

2. Select the stroke square from the tool bar [X].

3. Stroke the image by clicking on a color from the Swatches Palette window.

4. Change the size of the stroke by clicking on the blue arrow to the immediate right of the stroke input field.

5. Choose the designed stroke weight from the pop-up window or type in the desired weight.

31

1

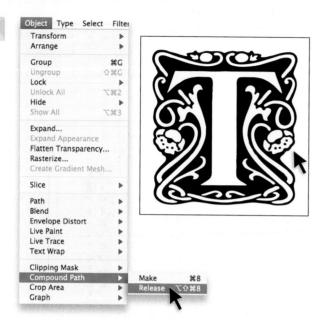

2

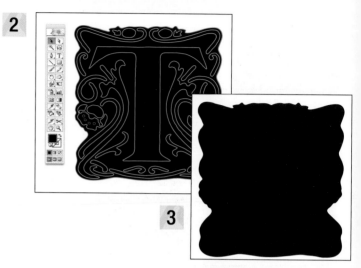

3

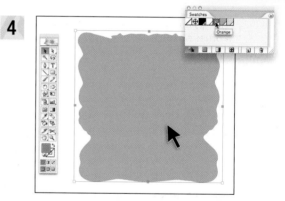

In order to work (color, stroke, drop shadow, etc.)
with the individual cells in a compound path,
you need to release the compound path.

1. Select the image using the Selection Tool
 found at the top left corner of the tool bar [V].

 Go to the drop-down menu Object>Compound
 Path>Release on the top menu bar.

2. Your image should look similar to Figure 2.
 Each individual shape that comprises the
 image is highlighted.

 These shapes are now independent of each other.

3. Deselect the image.

4. Select the image again and fill the top shape
 with a color.

5. With the shape still selected go to the drop-down
 menu Object>Arrange>Send to Back on the
 top menu bar.

4

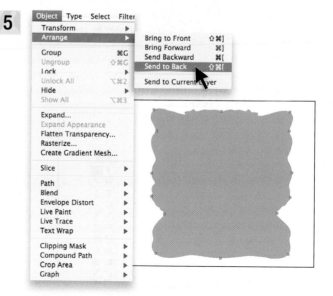

5

6

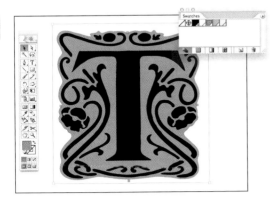

6. The colored shape should now be behind all the other shapes.

7

7. Select one of the black shapes remaining and fill with a color.

8

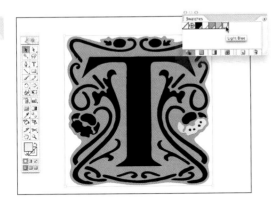

8. Once a new color has been applied to the shape, your image should look similar to Figure 8.

9

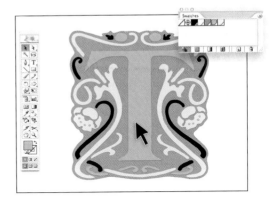

9. Continue selecting the shapes and filling them with color to complete the image.

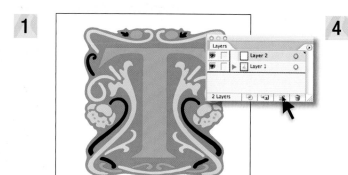

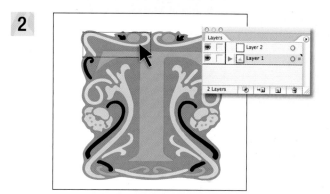

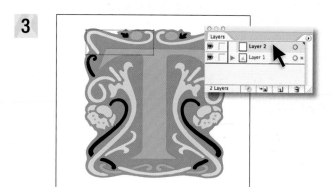

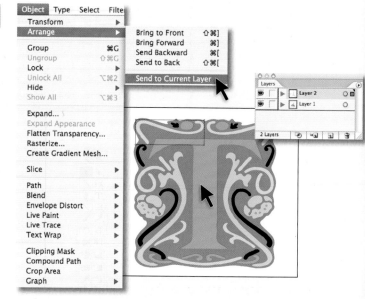

1. On the top menu bar, go to the drop-down menu Window>Layers to open the Layers window. Create a new layer by clicking the New Layer button located in the lower right corner next to the trash can.

2. Select the images or shapes you want to move to a new layer using the Selection Tool found at the top left corner of the tool bar [V].

3. With the images still highlighted, reselect the new layer (layer 2) by clicking the radio button next to the layer name.

4. On the top menu bar go to the drop-down menu Object>Arrange>Send to Current Layer. This will send all the shapes selected in step 2 to layer 2.

1

2

3

4

5

6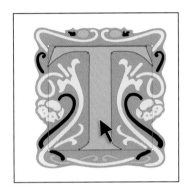

7

8

1. On the top menu bar, go to the drop-down menu Window>Swatches and Window>Gradient. This will open the Swatches and Gradient Palette windows.

2. Select the color you want to make into a gradient from the Swatches Palette and hold the left mouse button down while dragging the color swatch to the Gradient Palette window.

3. The swatch is placed on either the left or right hand swatch boxes on the gradient slider. The basic gradient should look similar to Figure 3. You can adjust the gradient by moving the sliders and by dragging additional color swatches to the Gradient Palette window.

4. In the upper left hand corner of the Gradient Palette window will be the gradient you have just created. Select it and hold the left mouse button down while dragging it to the Swatches Palette.

 Note: The All Swatches button at the bottom of the Swatches Palette must be clicked in order to see regular colors together with gradients.

5. Your Swatch Palette should look similar to Figure 5.

6. Select the image you want to apply your new gradient to using the Selection Tool found at the top left corner of the tool bar [V].

7. Select your new gradient from the Swatches Palette. Your image should look similar to Figure 7.

8. To change the angle of a gradient, select the object containing the gradient, then type in a new angle in the angle input field in the Gradient Palette window.

Clipping Masks in Illustrator

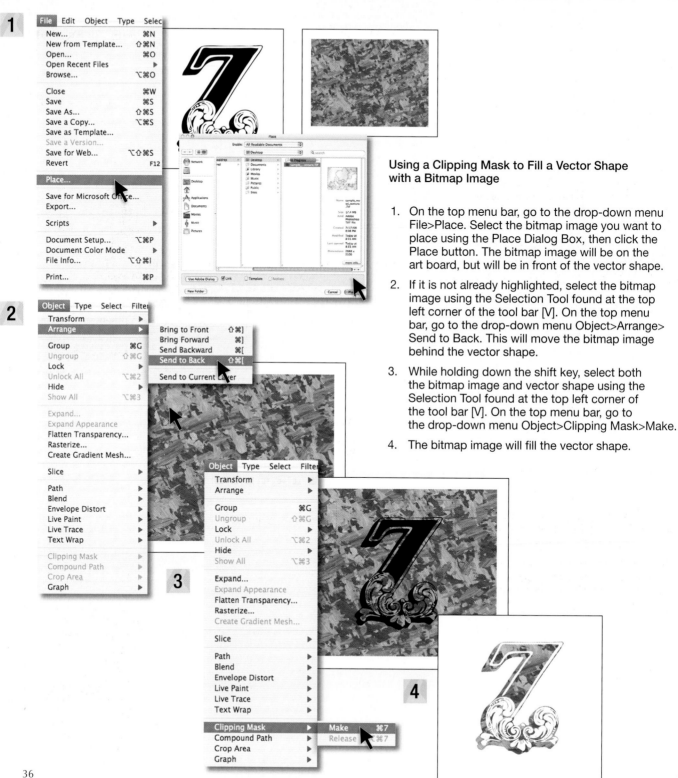

Using a Clipping Mask to Fill a Vector Shape with a Bitmap Image

1. On the top menu bar, go to the drop-down menu File>Place. Select the bitmap image you want to place using the Place Dialog Box, then click the Place button. The bitmap image will be on the art board, but will be in front of the vector shape.

2. If it is not already highlighted, select the bitmap image using the Selection Tool found at the top left corner of the tool bar [V]. On the top menu bar, go to the drop-down menu Object>Arrange> Send to Back. This will move the bitmap image behind the vector shape.

3. While holding down the shift key, select both the bitmap image and vector shape using the Selection Tool found at the top left corner of the tool bar [V]. On the top menu bar, go to the drop-down menu Object>Clipping Mask>Make.

4. The bitmap image will fill the vector shape.

Opening an EPS Vector in Photoshop

1. On the top menu bar, go to the drop-down menu File>Open. In the Open window, find and select the EPS Vector file you want to open and click the Open button.

2. In the Rasterize Generic EPS Format window, be sure to select a size that is large enough to fill your document. Because you are rasterizing the EPS, you will not be able to scale the image again without losing quality.

 Remember when working with pixel-based formats in Photoshop, it is always easier to scale down than up. Only EPS Vector files allow you to scale your images without loss of quality before embedding them into your Photoshop document. Not all EPS files are true vector-based objects.

Placing an EPS Vector in Photoshop

1. Be sure to have a blank or working document already open.

2. On the top menu bar, go to the drop-down menu File>Place. In the Open window, find and select the EPS Vector file you want to place and click the Place button.

3. The EPS Vector will be placed in your blank document and will retain many of its vector-based qualities until it is rasterized. In Photoshop, this is called a Smart Object, since you can still edit it in its native format with a program such as Adobe Illustrator. Read more about Smart Objects in your Photoshop Web Help or the manual that accompanied your software.

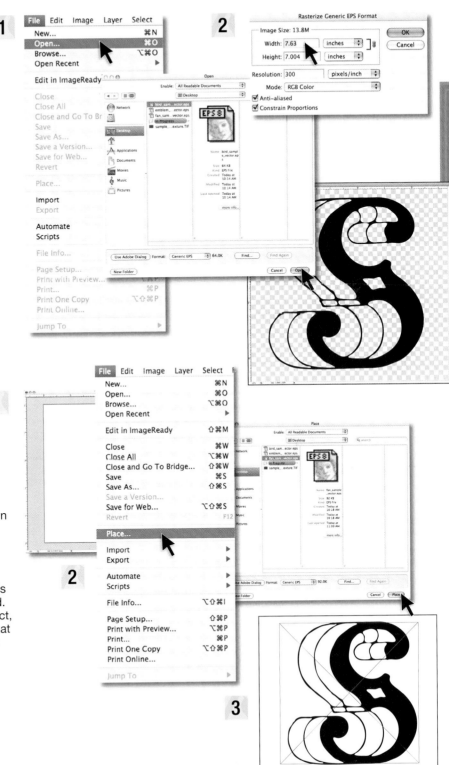

Selecting Areas with the Magic Wand in Photoshop

1

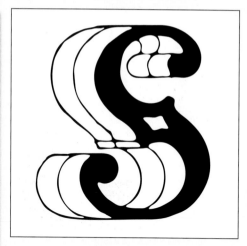

2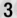

3

1. Select the Magic Wand Tool [W] found in the tool bar.

2. Enter a value in the Tolerance field found near the top menu bar. The higher this value, the wider the range of colors that will be selected. You can change this value in accordance to the type of image you are using.

3. Select an area of the image.

Adding Color with the Paint Bucket in Photoshop

1

2

1. Select the Paint Bucket Tool [G] found in the tool bar.

 The Paint Bucket will use the color assigned to the foreground color box

2. Paint the object by clicking on it.

1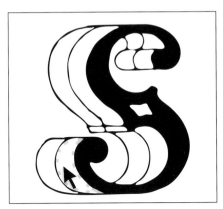

2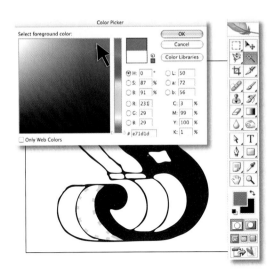

3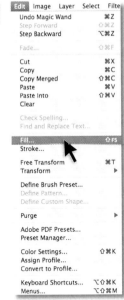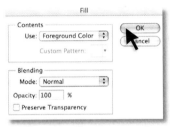

4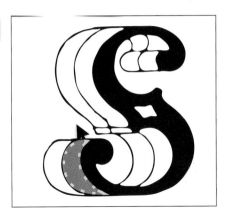

TUTORIALS

1. Select an area of the image using the Magic Wand Tool [W] found in the tool bar.

2. Double-click the Foreground Color box found at the bottom of the tool bar and open the Color Picker Palette. Select a color and click OK. The new color should display in the Foreground Color box in the tool bar.

3. On the top menu bar, go to the drop-down menu Edit>Fill. Select Foreground Color from the Fill Dialog Box and click OK.

4. The section will be filled with the foreground color.

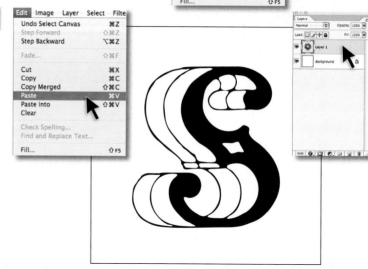

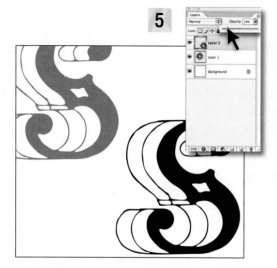

1. On the top menu bar, go to the drop-down menu File>New and create a new blank document.

2. On the top menu bar, go to the drop-down menu File>Open; find and select the EPS Vector file you want in your new document; click the Open button. On the top menu bar, go to the drop-down menu Select>All, then go to the drop-down menu Edit>Copy.

3. Go to the Layers window in the new blank document made in step 1, and create a new layer by clicking on the New Layer button at the lower right corner next to the trash can.

4. On the top menu bar, go to the drop-down menu Edit>Paste. The vector shape copied in step 2 should now be on Layer 2. Repeat Steps 3 and 4 to add additional layers and images.

5. To change the opacity of a layer, select the layer; click the arrow to the right of the Opacity field, and use the slider to manipulate the opacity.

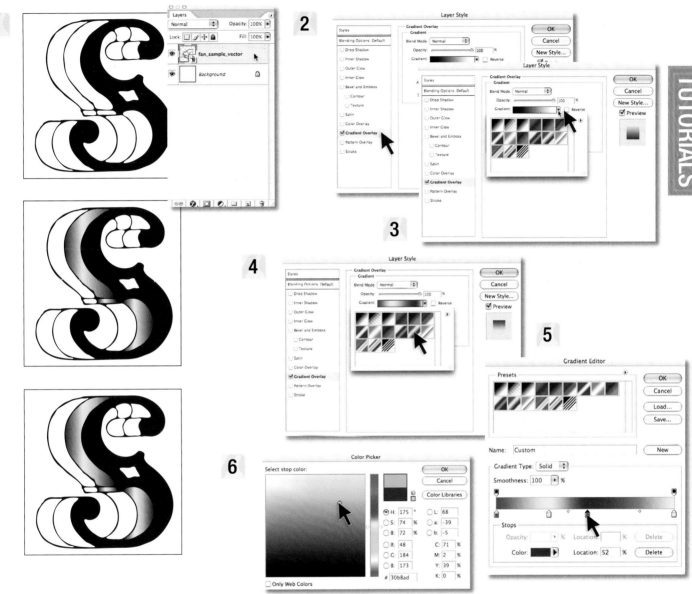

TUTORIALS

1. In the Layers window, double-click the layer you want to add a style to. This will open the Layer Style window.
2. In this window, select Gradient Overlay in the list of styles at the left of the window to open the Gradient Options window.
3. Click the arrow at the right end of the gradient sample bar.
4. Choose a gradient from the pop-up menu.
5. Click the gradient swatch to open the Gradient Editor window. Click on any of the color stop boxes to choose new colors.
6. In the Color Picker window, select a new color and click OK.

 You can also change the position of the color stop boxes by sliding them along the gradient bar.

1. Open a line art EPS image from the CD. (see page 37) Then convert its color space to RBG by going to the top menu bar, drop-down menu Image>Mode>RGB.

2. Open a background texture image from the CD.

3. Select a cell of the image using the Magic Wand Tool [W] found in the tool bar. (See page 38)

 Be sure to set the tolerance at 32, with both Anti-Alias and Contiguous checked when making your selection.

 Smooth the selection 2 pixels via the top menu bar, drop-down menu Select>Modify>Smooth. Click OK.

 Then expand the selection by 2 pixels by going to the top menu bar, drop-down menu Select>Modify>Expand. Click OK.

4. Click on the texture document you want to incorporate into the selected cell.

 On the top menu bar, go to the drop-down menu Select>All. This should select the entire image.

 Then from the top menu bar, go to the drop-down menu Edit>Copy. This will copy the selection.

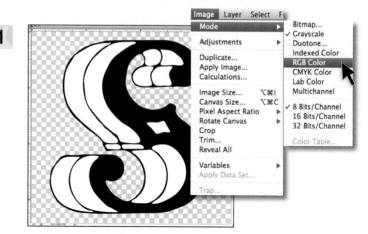

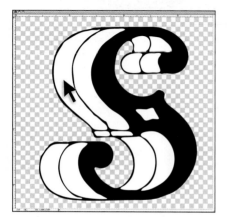

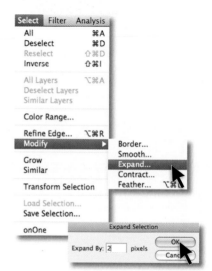

4

5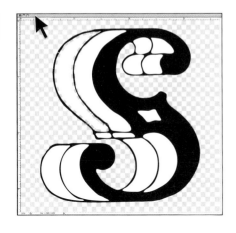

5. Click back on the line art image. Be sure
 a cell is still selected, if not repeat step 3.

 On the top menu bar, go to the drop-down
 menu Edit>Paste Into. The copy (step 4) of the
 texture image should be pasted inside the
 selected cell.

 Repeat Steps 2 thru 5 to finish filling
 in the cells.

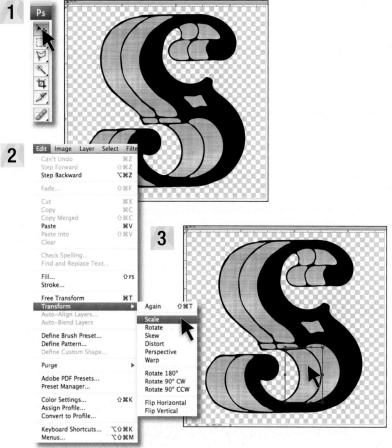

Once the texture images have been pasted into the line art (see pages 42–43), they can then be transformed to achieve more realistic effects.

1. To scale the texture, select an individual layer with the Selection Tool [V] found at the top of the tool bar. This should also highlight the Layer the texture is on as well.

2. On the top menu bar, go to the drop-down menu Edit>Transform>Scale.

3. Scale the image using the handles that pop-up around the selection.

 When the image has been scaled to your liking simply double click the left mouse button and the transform will be set.

4. To rotate the texture select an individual layer with the Selection Tool [V] found at the top of the tool bar.

5. On the top menu bar, go to the drop-down menu Edit>Transform>Rotate.

6. Rotate the image using the handles that pop-up around the selection.

 When the image has been rotated to your liking simply double click the left mouse button and the transform will be set.

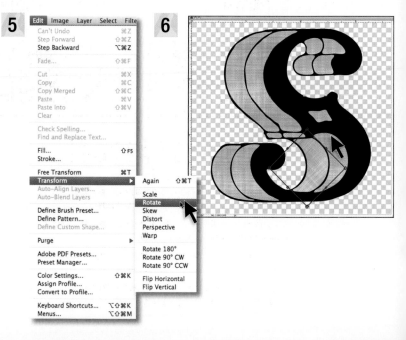

Changing the Hue of the Texture in Photoshop

The expressive range of the 40 texture samples supplied on the CD can be dramatically expanded by using the Hue and Saturation function in Photoshop.

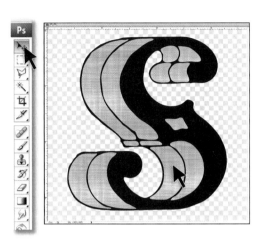

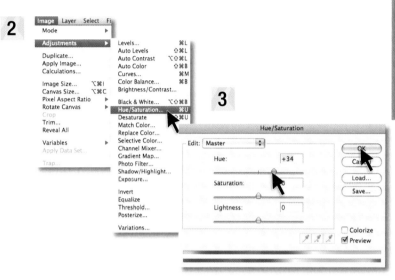

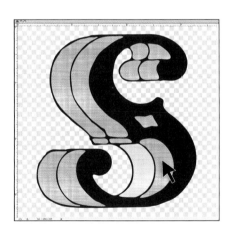

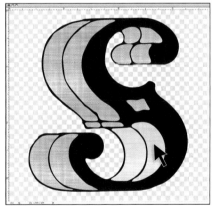

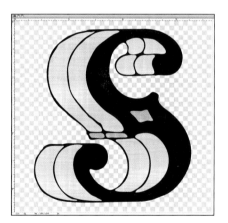

1. To change the color of the textures select an individual layer with the Selection Tool [V] found at the top of the tool bar.

2. On the top menu bar, go to the drop-down menu Image>Adjustments>Hue/Saturation.

3. In the Hue/Saturation dialog box simply vary the color using the Hue Slider Bar.

 Once you have the color that you want click the OK button to set the new color.

 Continue this process to create a visually stunning piece of digital art.

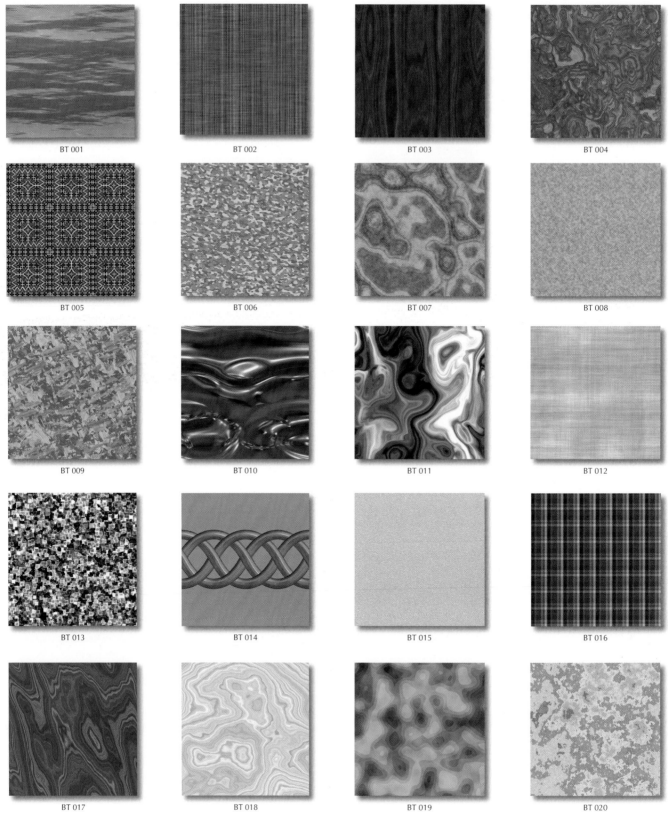

BT 001 BT 002 BT 003 BT 004

BT 005 BT 006 BT 007 BT 008

BT 009 BT 010 BT 011 BT 012

BT 013 BT 014 BT 015 BT 016

BT 017 BT 018 BT 019 BT 020

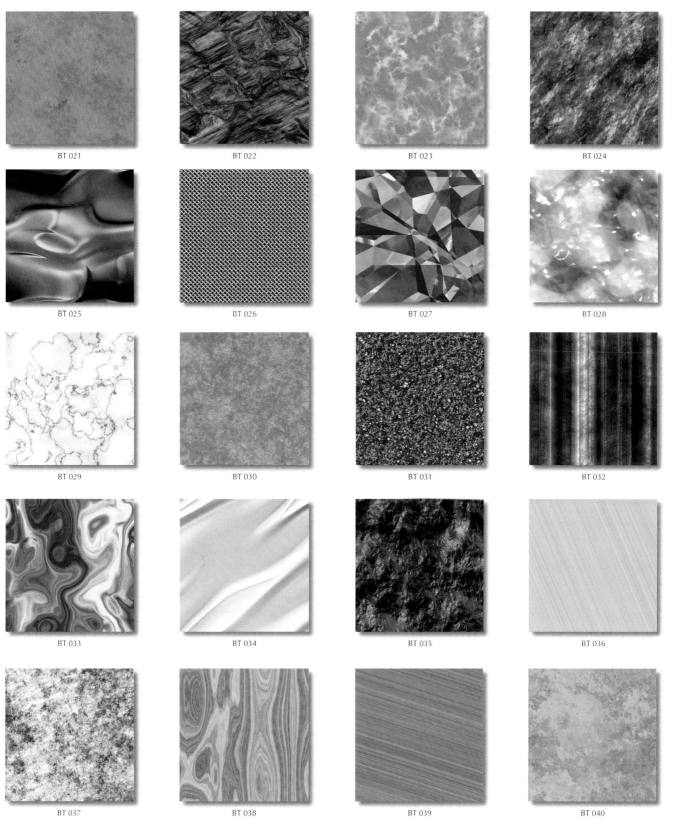

BT 021

BT 022

BT 023

BT 024

BT 025

BT 026

BT 027

BT 028

BT 029

BT 030

BT 031

BT 032

BT 033

BT 034

BT 035

BT 036

BT 037

BT 038

BT 039

BT 040

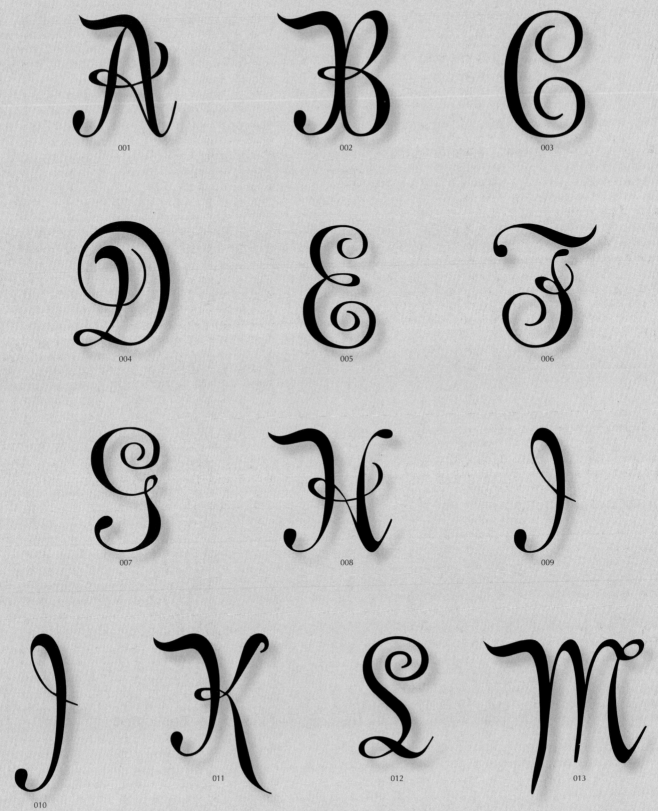

001 002 003
004 005 006
007 008 009
010 011 012 013

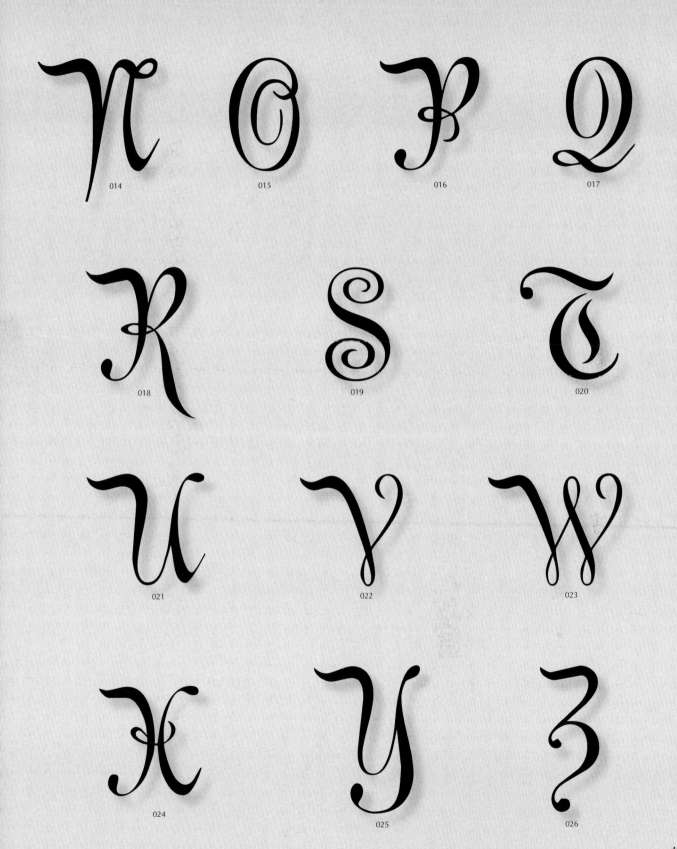

014 015 016 017
018 019 020
021 022 023
024 025 026

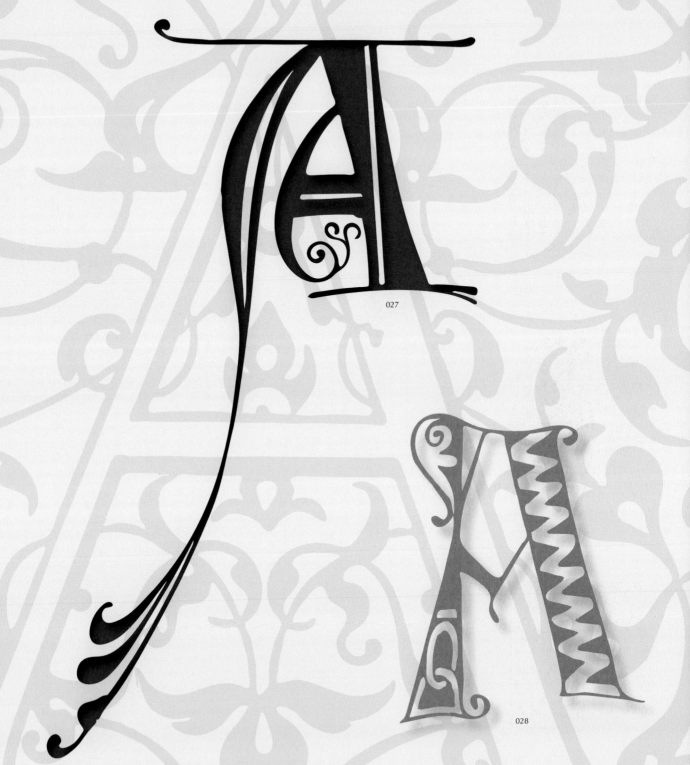

027

028

background 029

030

031

032

033

51

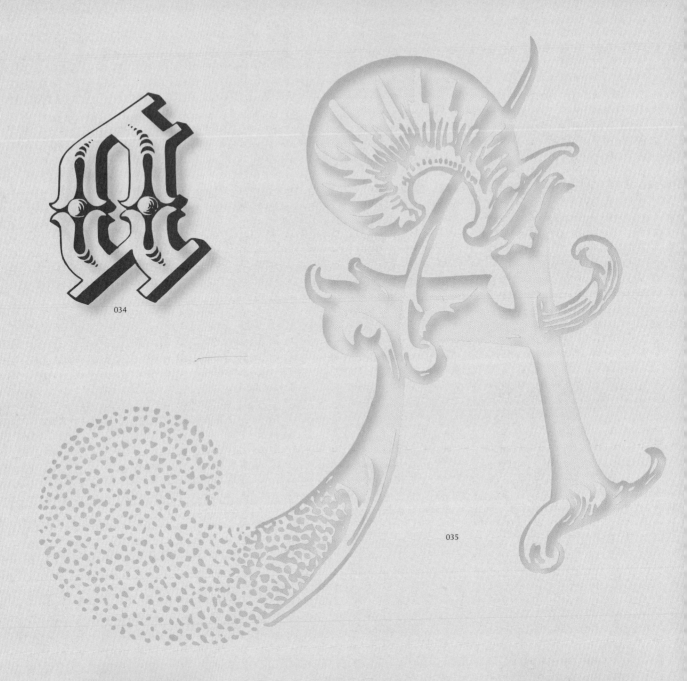

034

035

036

037

038

039

040

041

042

043

044

045

046

background 047

54

049

050

051

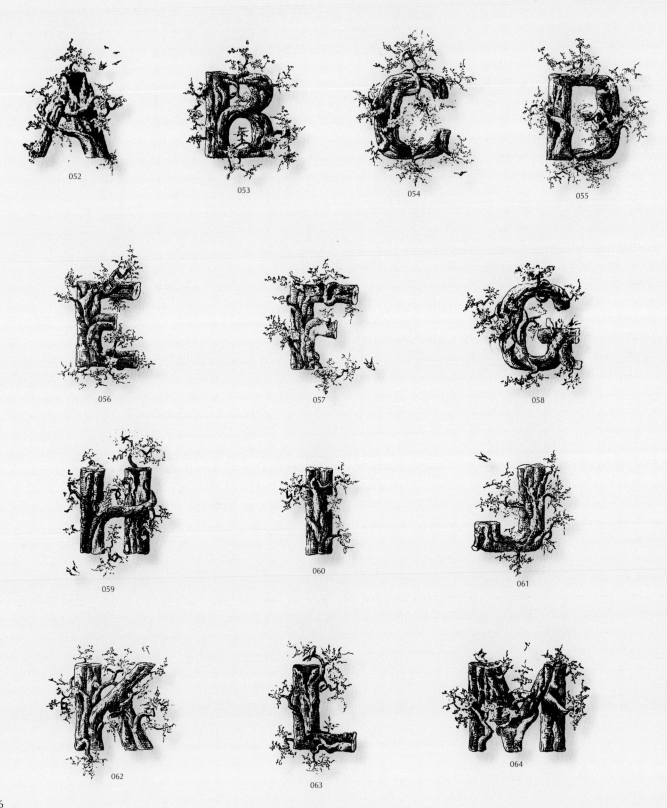

052

053

054

055

056

057

058

059

060

061

062

063

064

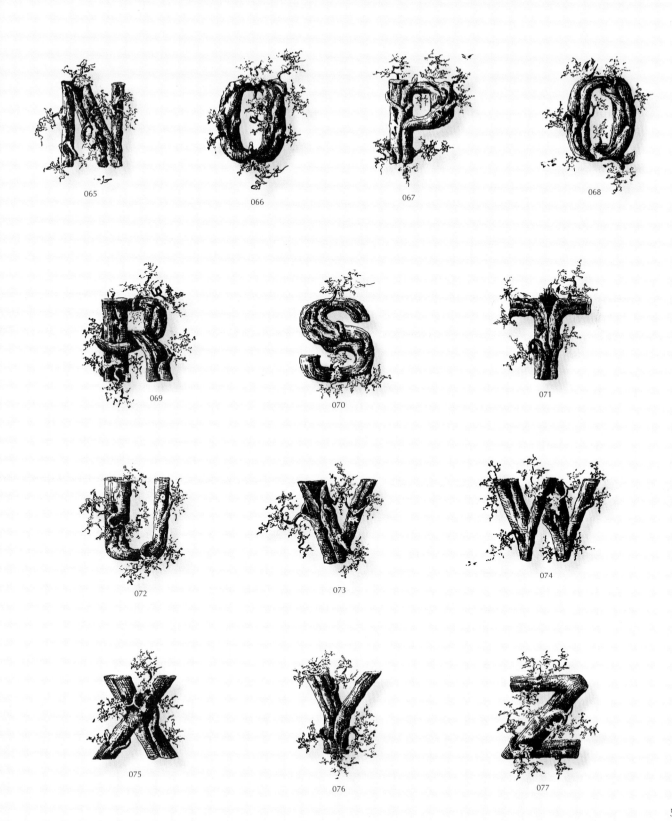

065

066

067

068

069

070

071

072

073

074

075

076

077

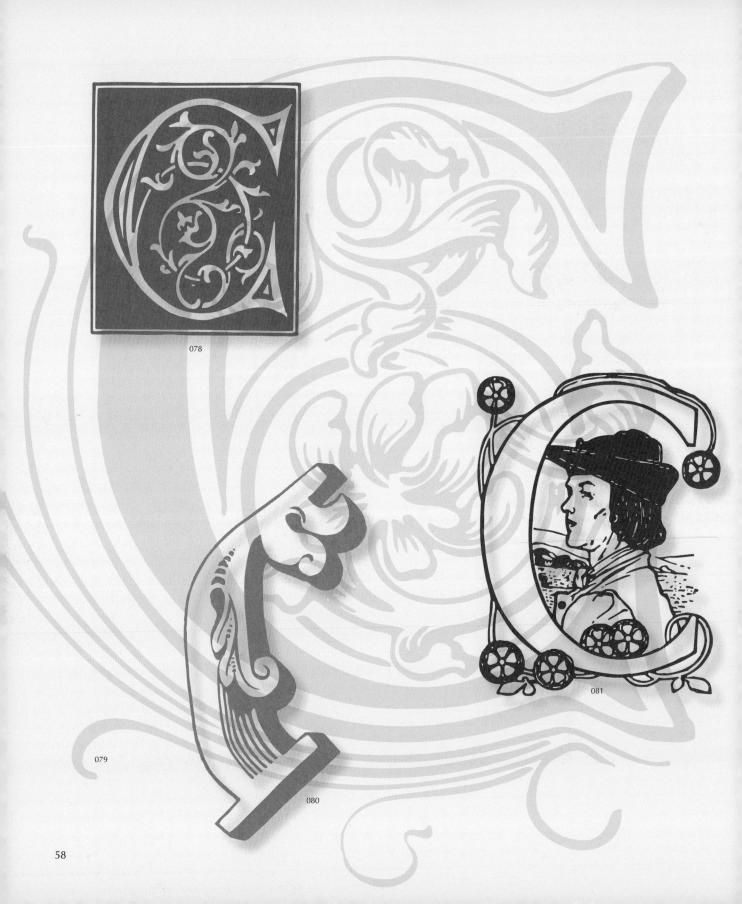

078

079

080

081

082

083

084

085

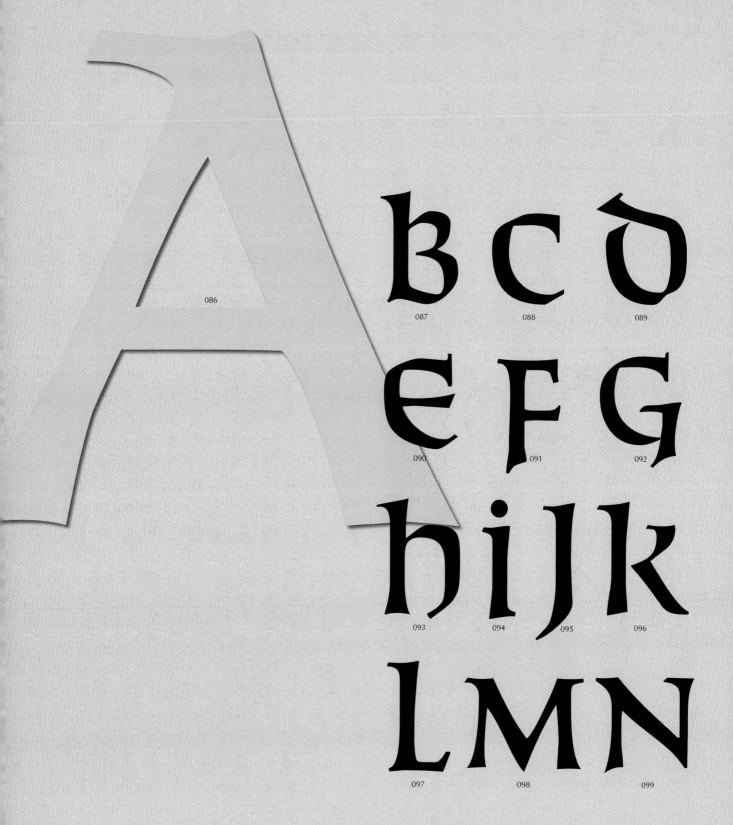

A 086
b 087 c 088 d 089
e 090 f 091 g 092
h 093 i 094 j 095 k 096
l 097 m 098 n 099

100 101 102

103 104 105

106 107 108

109 110

111

112

113

114

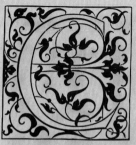

115

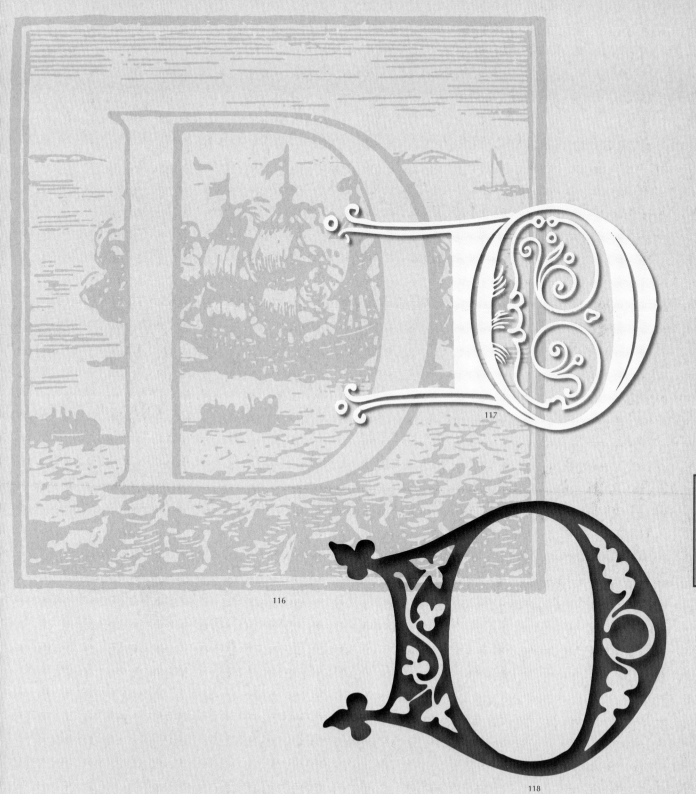

117

116

118

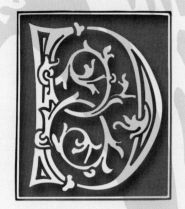

119

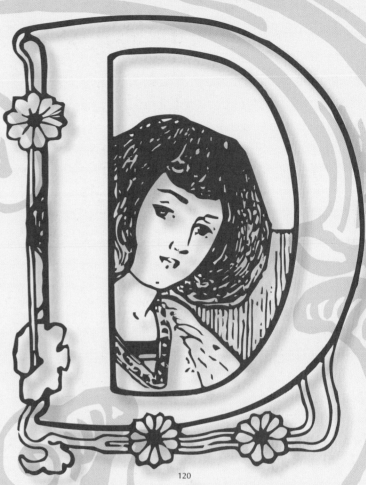

120

121

background 122

64

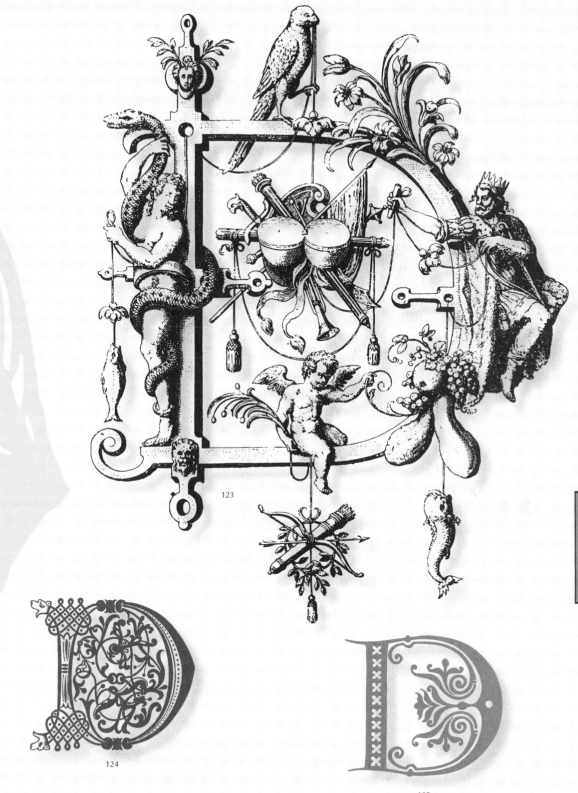

123

124

125

126

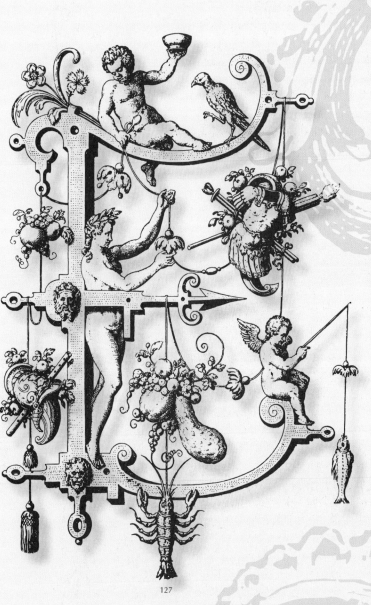

127

129

background 128

130

131

132

133

134

135

136

137

138

139

140

141

142

143

144

145

146

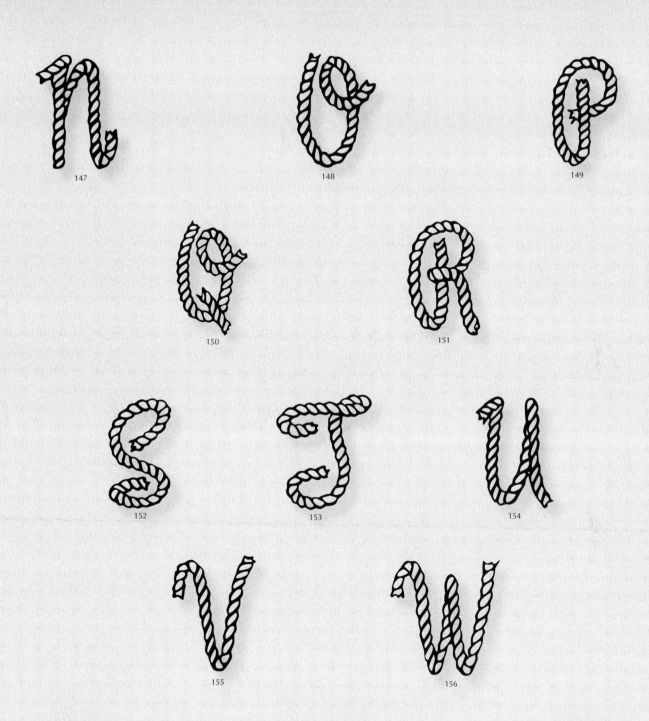

147

148

149

150

151

152

153

154

155

156

157

158

159

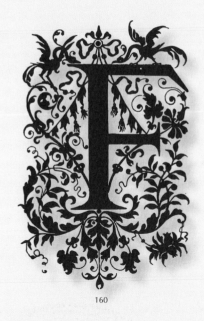

160

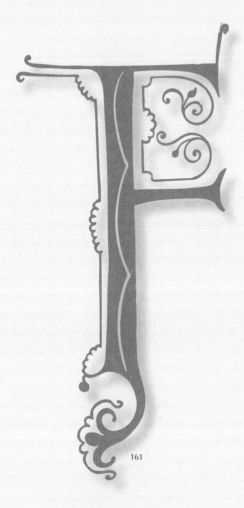

161

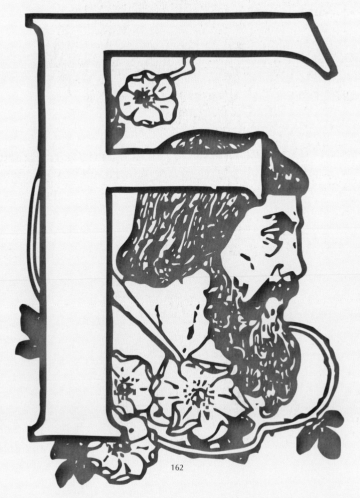

162

163

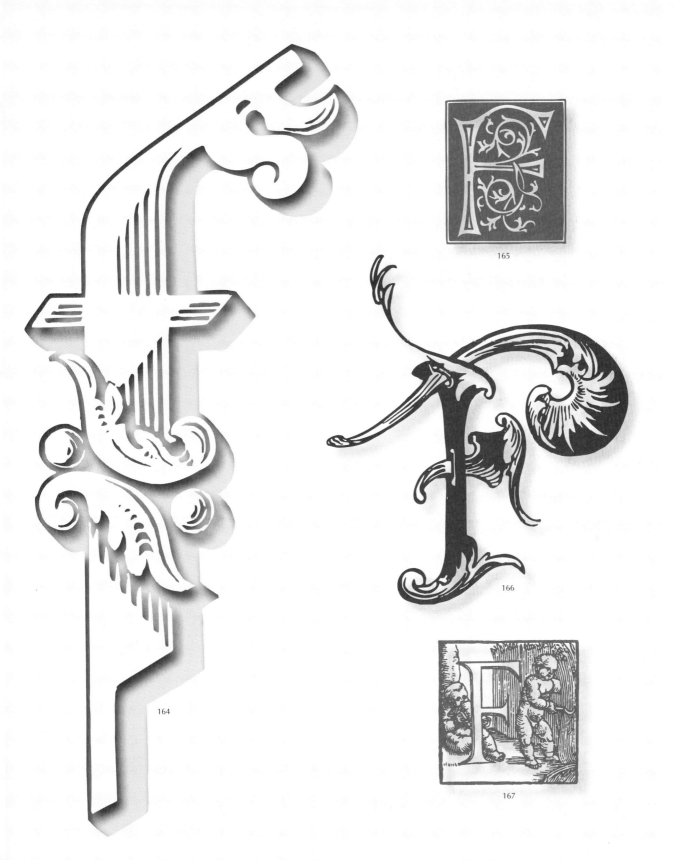

164

165

166

167

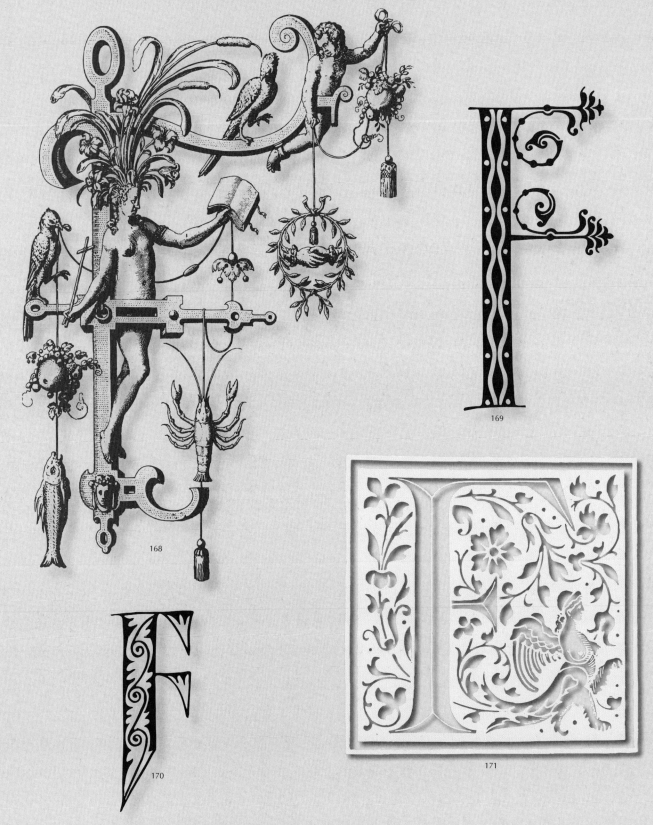

168

169

170

171

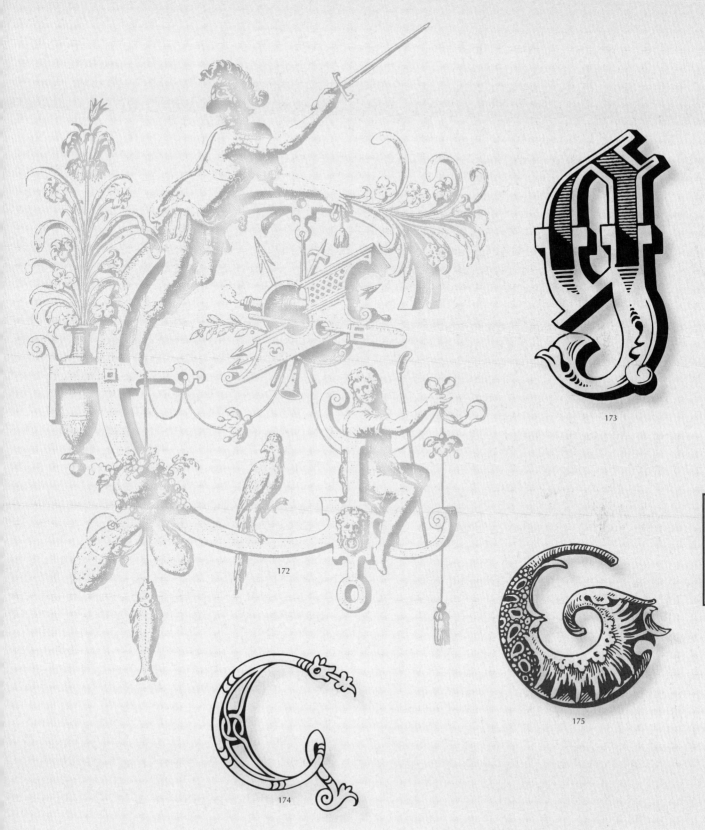

172

173

174

175

176

177

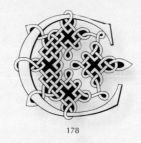

178

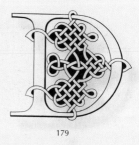

179

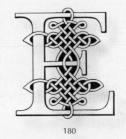

180

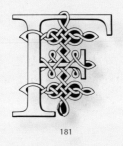

181

182

183

184

185

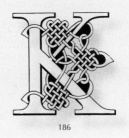

186

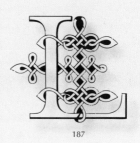

187

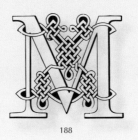

188

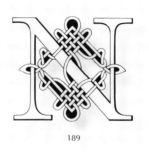

189

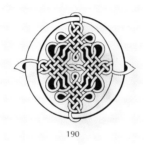

190

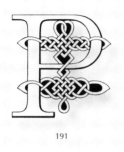

191

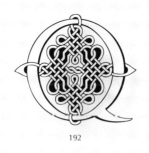

192

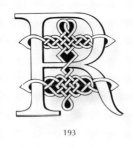

193

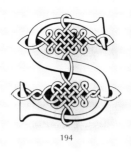

194

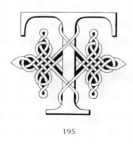

195

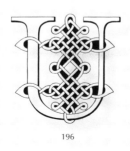

196

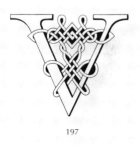

197

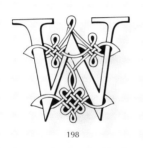

198

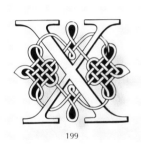

199

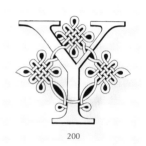

200

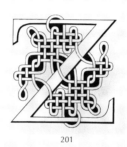

201

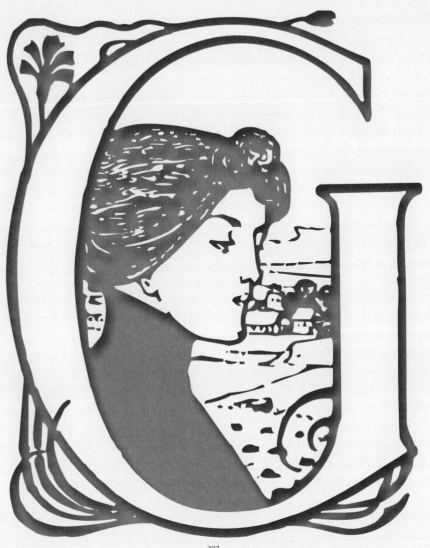

202

203

204

205

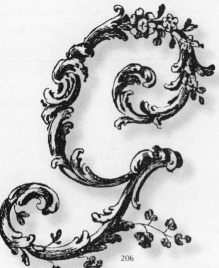

206

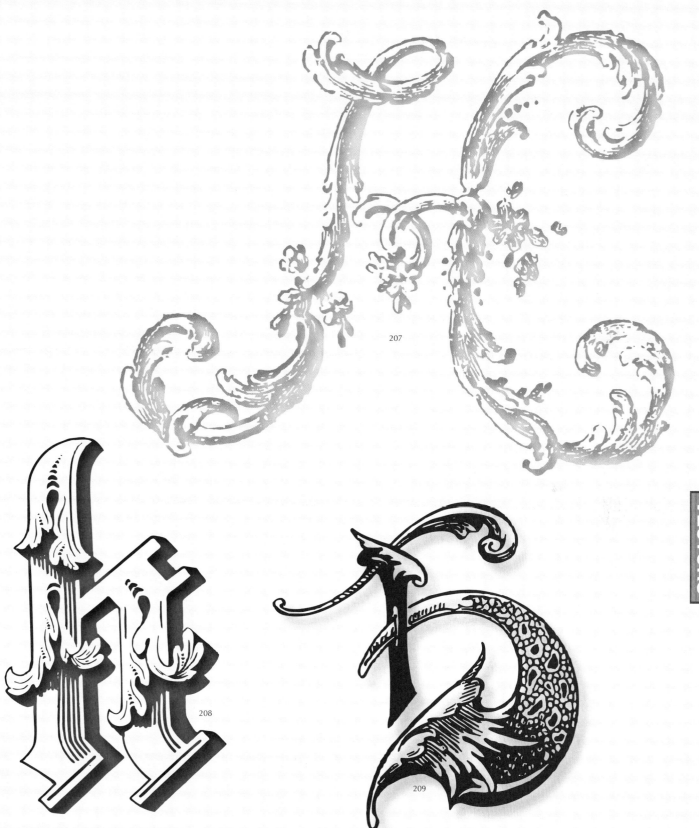

207

208

209

210

211

212

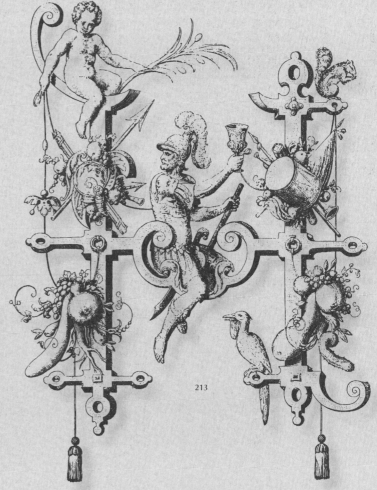

213

214

215

216

217

218

219

220

221

222

223

224

225

226

227

228

229

230

231

232

233

234

235

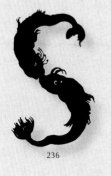

236

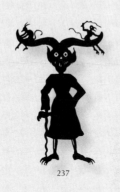

237

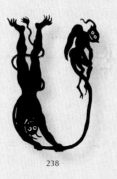

238

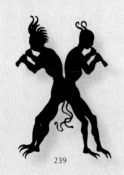

239

240

241

242

243

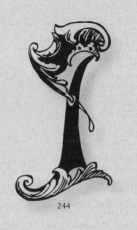

244

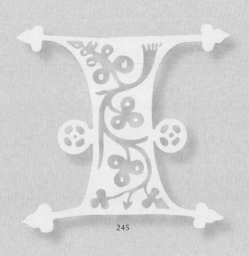

245

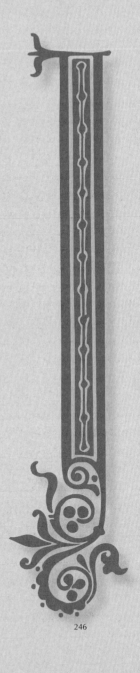

246

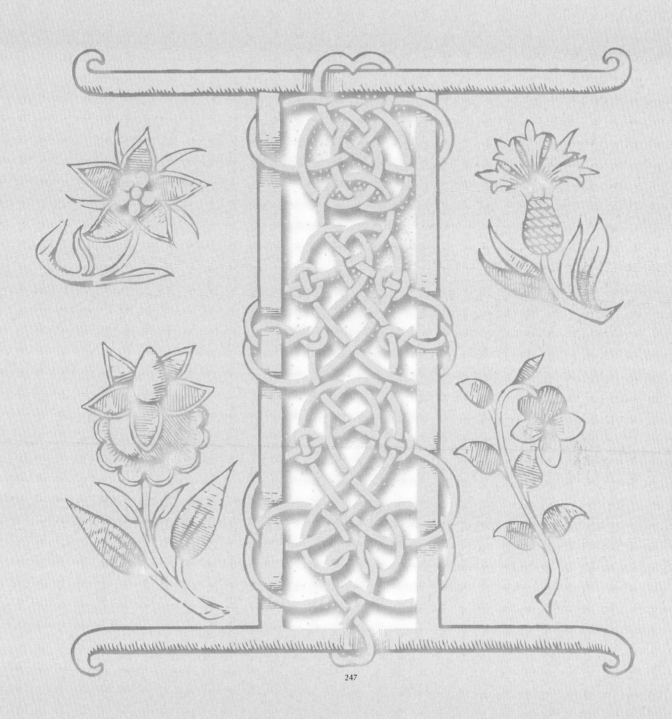

247

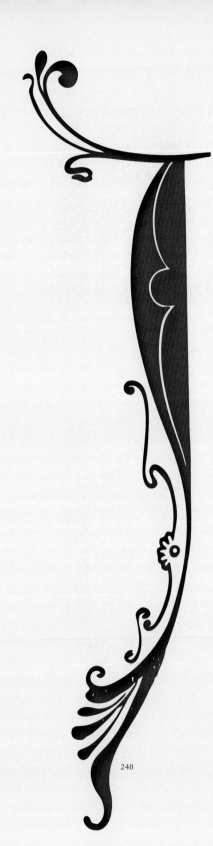

248

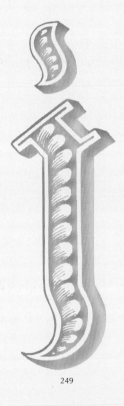

249

250

251

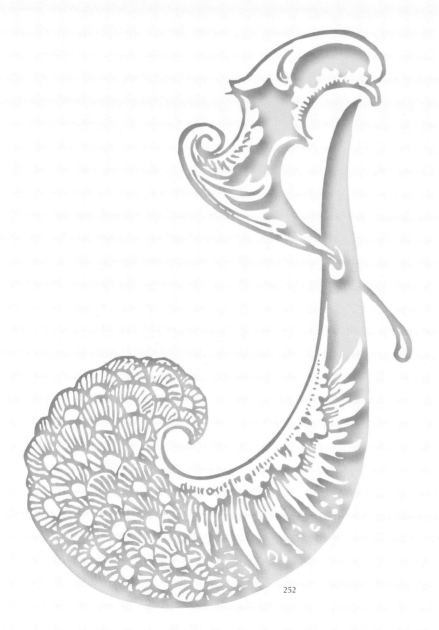

252

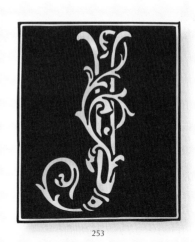

253

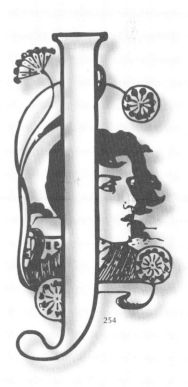

254

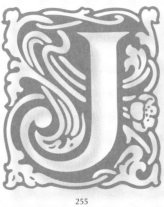

255

256

257

258

259

260

261

262

263

264

265

266

267

268

269

270

271

90

272

273

274

275

276

92

277

278

279

280

281

282

283

284

285

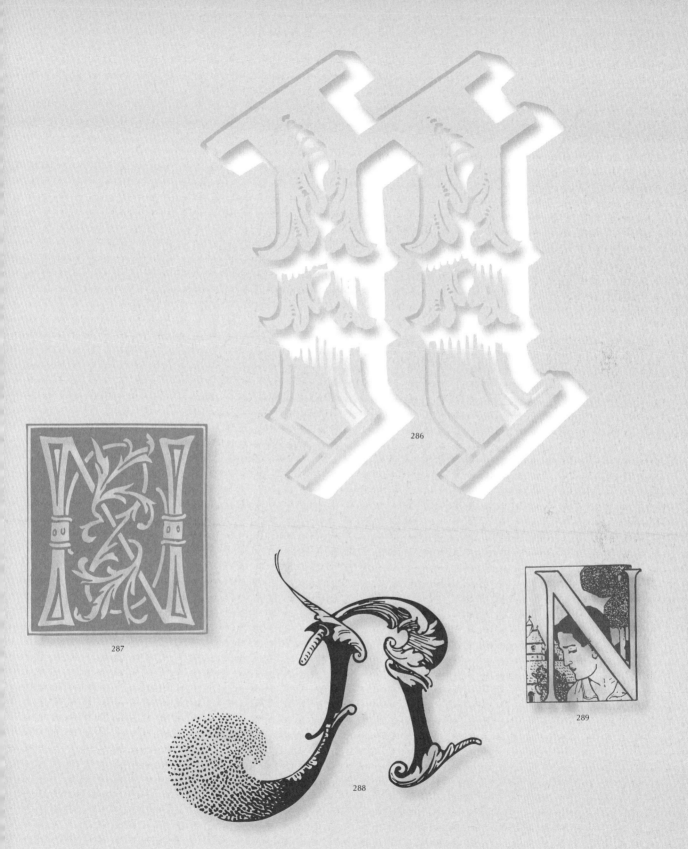

286

287

288

289

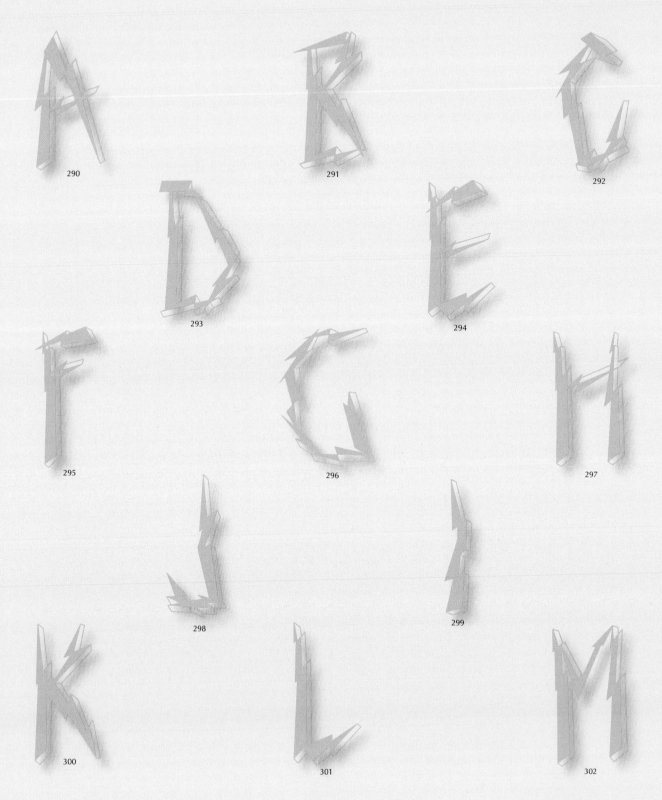

290

291

292

293

294

295

296

297

298

299

300

301

302

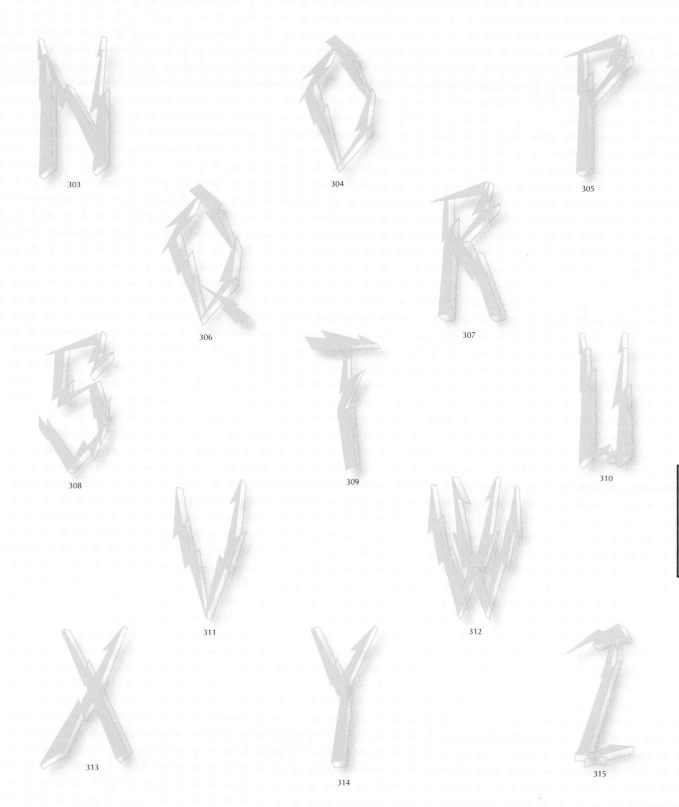

303

304

305

306

307

308

309

310

311

312

313

314

315

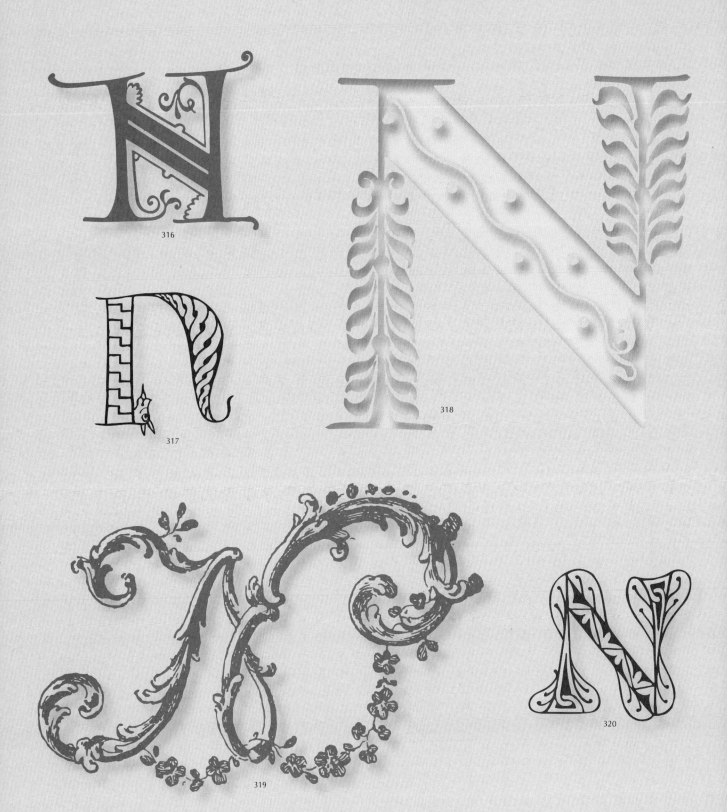

316

317

318

319

320

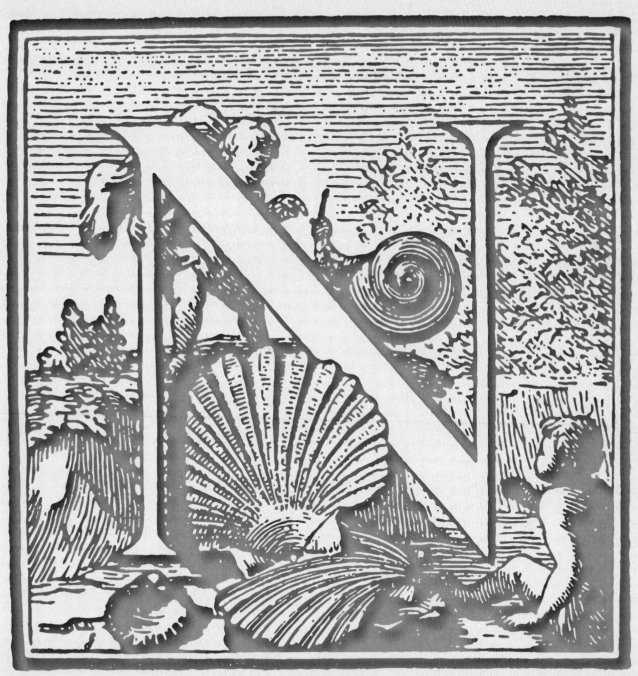

321

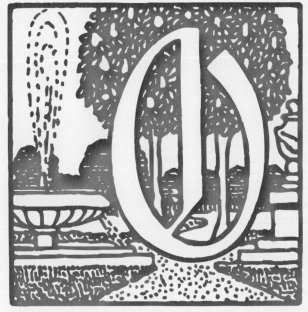

322

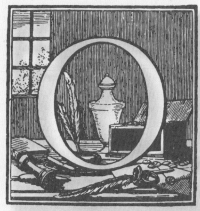

323

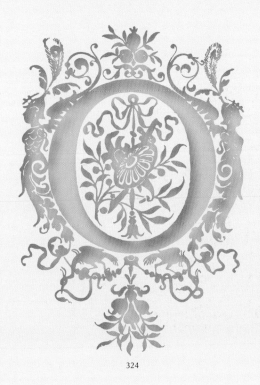

324

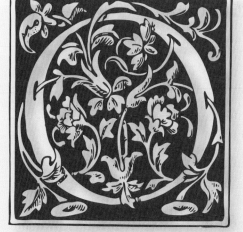

325

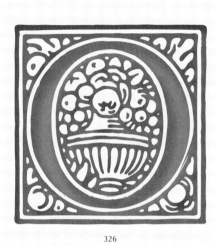

326

327

328

329

330

331

332

333

334

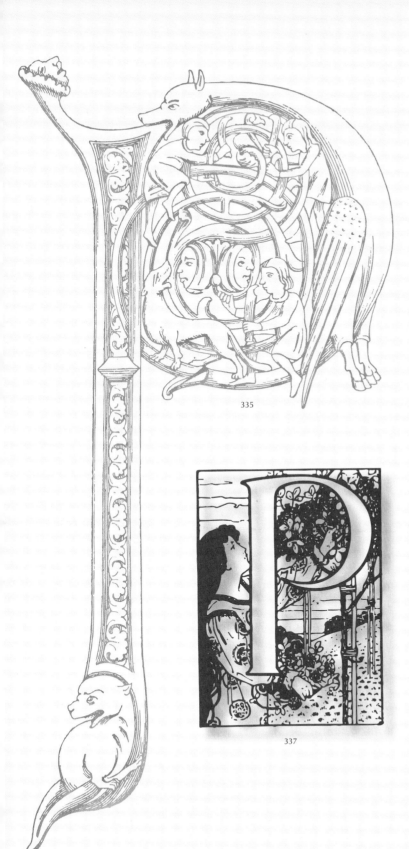

335

336

337

338

339

340

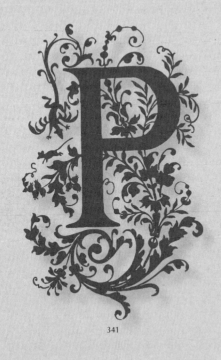

341

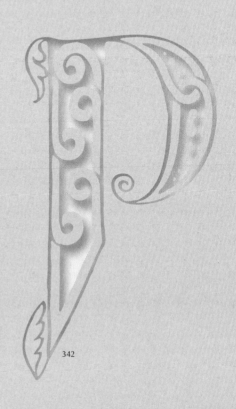

342

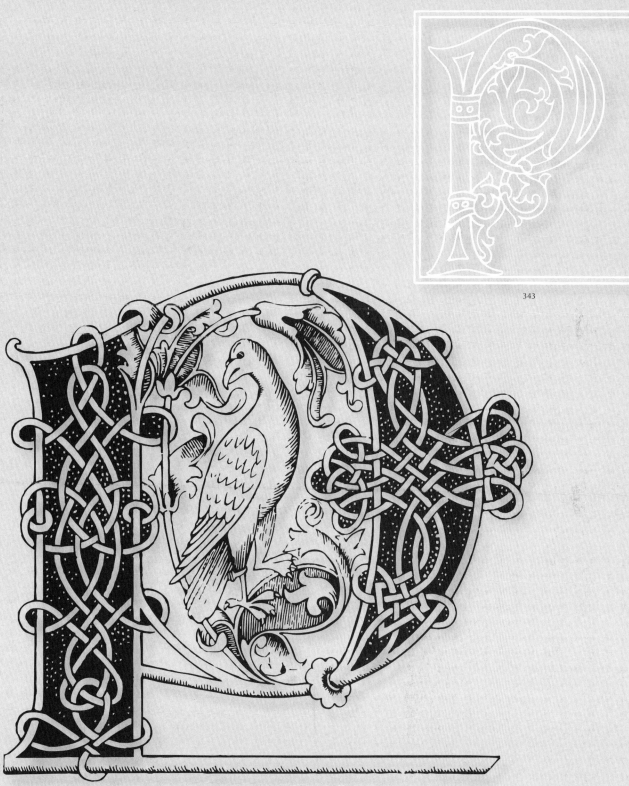

343

344

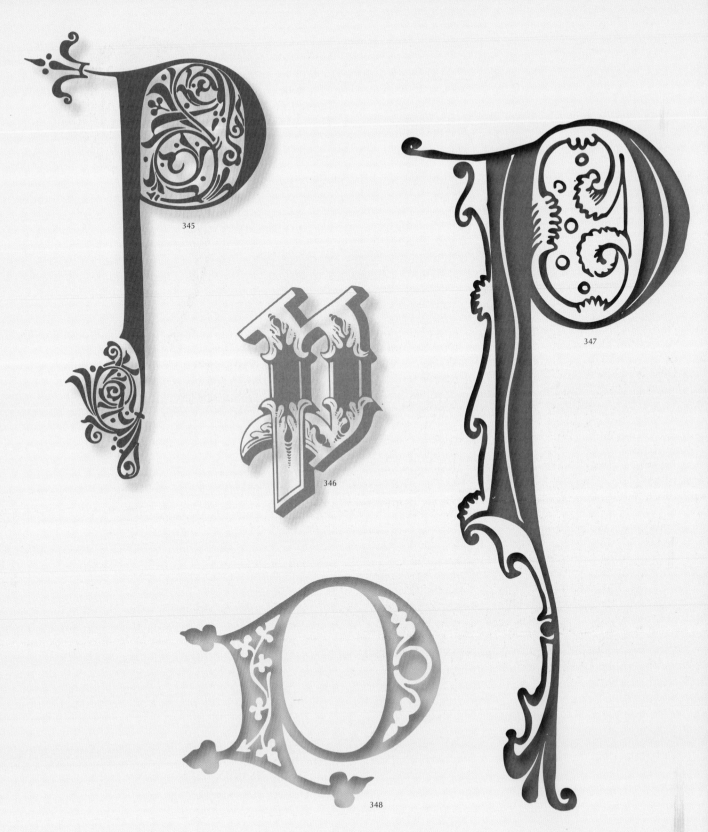

345

346

347

348

349

350

351

352

353

354

355

356

357

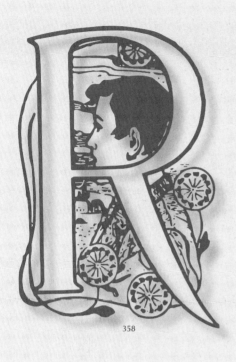

358

359

360

361

362

363

364

365

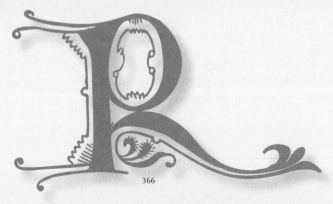

366

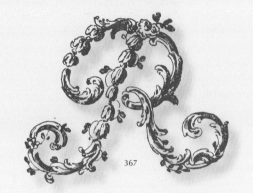

367

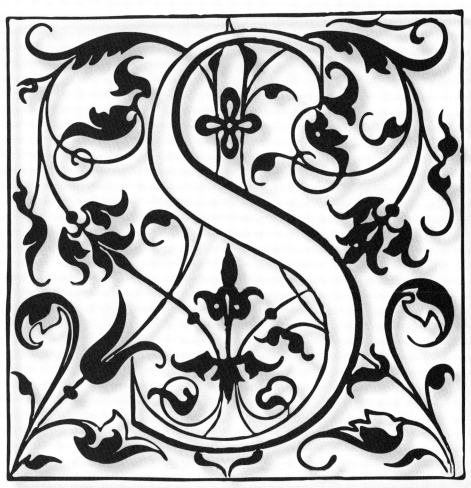

368

369

370

371

372

373

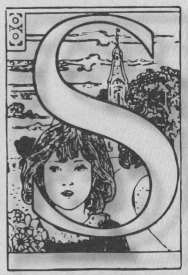

374

375

376

377

378

379

380

381

382

383

384

385

386

387

388

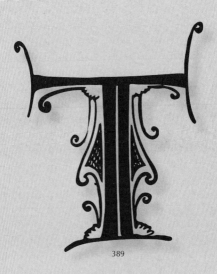

389

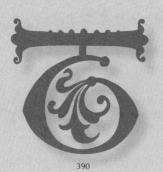

390

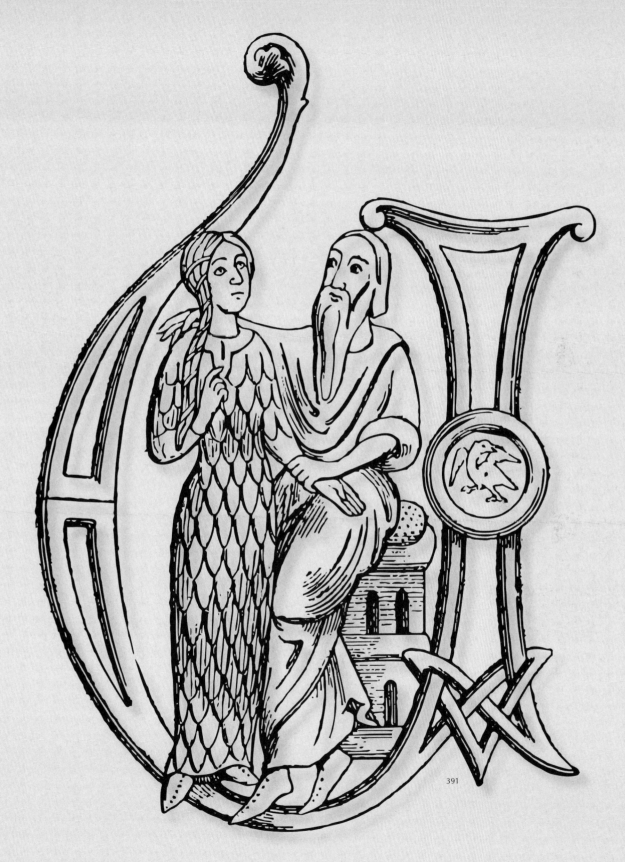

391

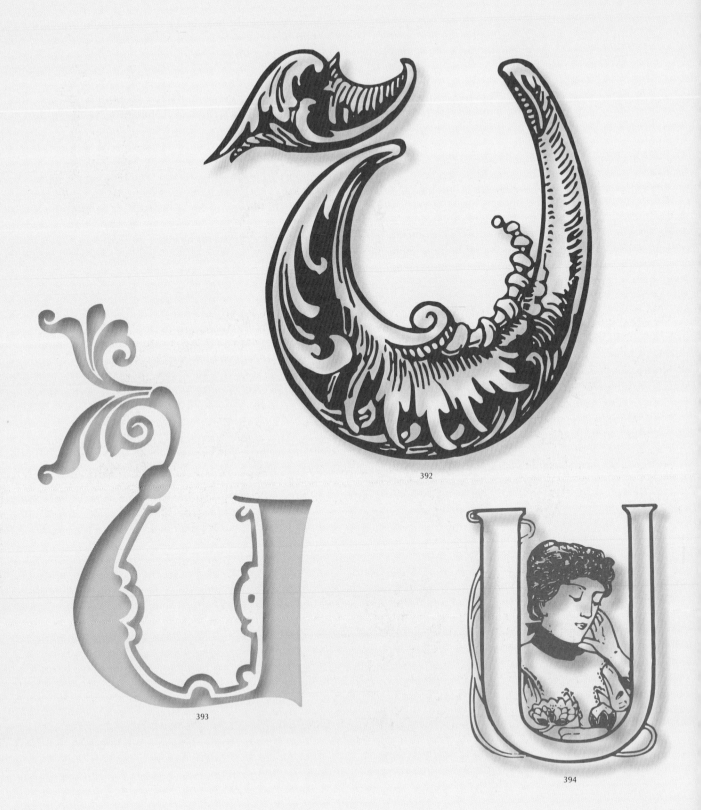

392

393

394

395

396

397

398

399

400

401

402

403

404

405

406

407

408

409

410

411

412

413

414

415

416

417

418

419

420

421

422

122

423

424

425

426

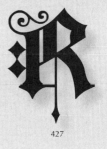

427

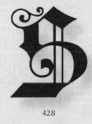

428

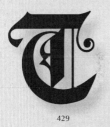

429

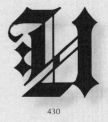

430

431

432

433

434

435

436

438

437

439

440

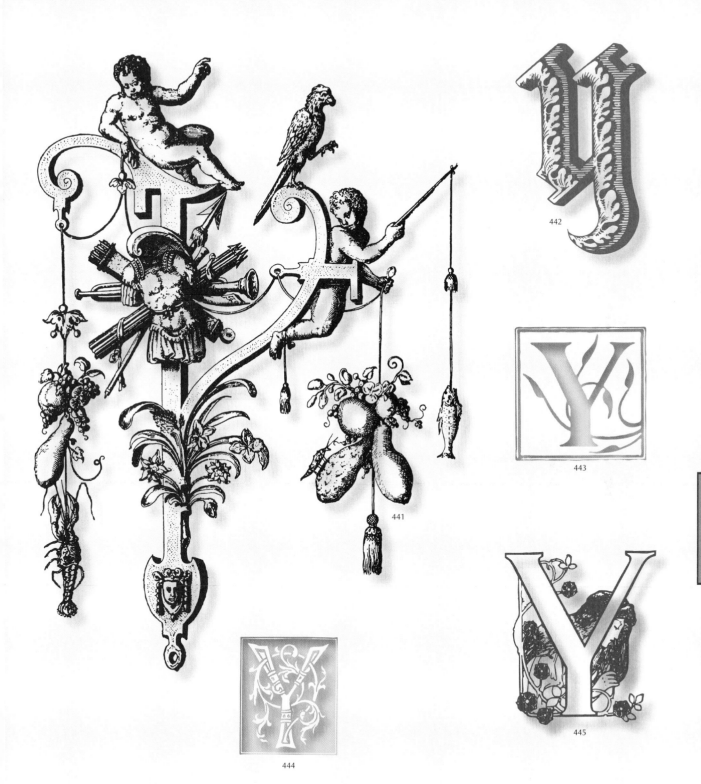

441

442

443

444

445

446

447

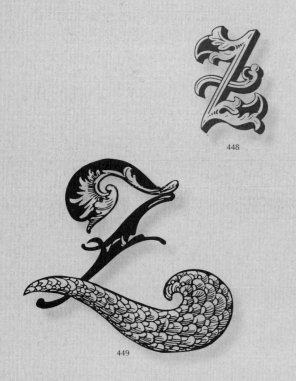

448

449

450

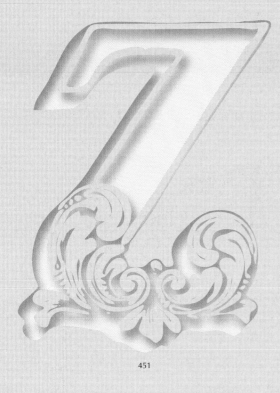

451

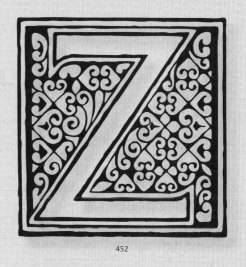

452

453

454

455

457

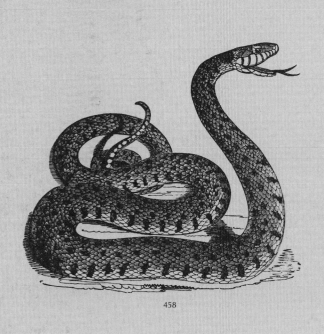

456

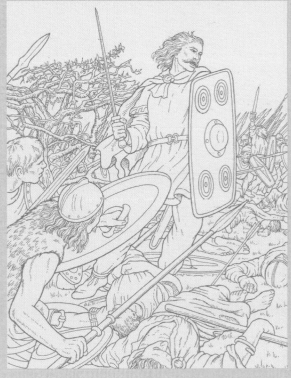

458

459